IMAGES
of Rail

MOUNT TAMALPAIS
SCENIC RAILWAY

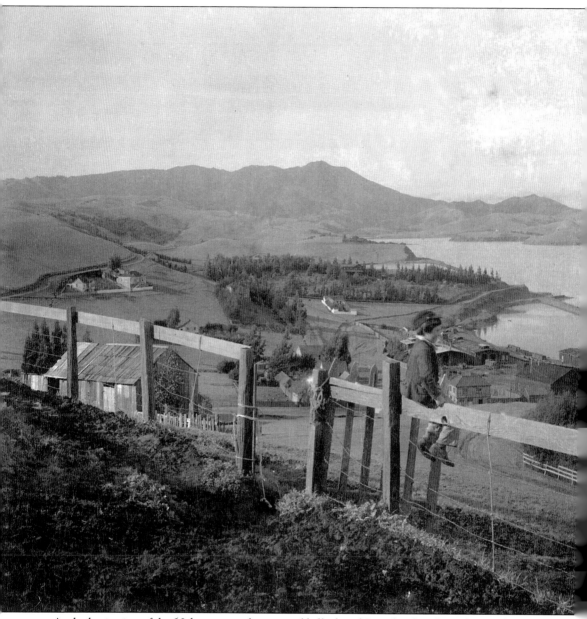

At the beginning of the 20th century, the pastoral hillsides of Sausalito lay along the North Pacific Railway route (waterfront, middle right) to Mount Tamalpais and the "Crookedest Railroad in the World." (Author's collection.)

ON THE COVER: Pictured around 1908 is engine No. 3 at the rustic Muir Woods Inn, the newest place of hospitality on the Mill Valley and Mount Tamalpais Scenic Railway.

IMAGES
of Rail

MOUNT TAMALPAIS
SCENIC RAILWAY

Fred Runner

ARCADIA
PUBLISHING

Published by Arcadia Publishing
Charleston, South Carolina

Printed in the United States of America

Library of Congress Catalog Card Number: 2008922703

For all general information contact Arcadia Publishing at:
Telephone 843-853-2070
Fax 843-853-0044
E-mail sales@arcadiapublishing.com
For customer service and orders:
Toll-Free 1-888-313-2665

Visit us on the Internet at www.arcadiapublishing.com

To Bill Provines in his 100th year,
who vividly remembers the best job he ever had;
and to writer, historian, and friend Ted Wurm,
who first chronicled the "Crookedest Railroad in the World."
Thanks for taking me on a most excellent adventure.

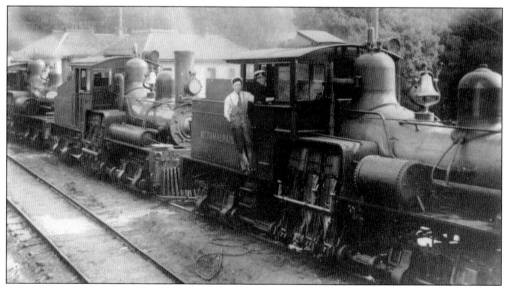

It is a busy morning on Corte Madera Avenue around 1910 as locomotives (from left to right) Nos. 3, 7, and 4 await their turn on the siding for fuel and water. Smiling Howard Folker is the engineer of No. 4. His fireman, dressed in a white shirt, tie, and greasy overalls, leans from the cab. At 10:50, these engines and their passenger cars will be on their way up Mount Tamalpais. (Ted Wurm collection.)

CONTENTS

ACKNOWLEDGMENTS

This book would not be possible without the passion of two men: Ted Wurm and his lifelong friend Al Graves. They wrote the first book about Mount Tamalpais's scenic railway in 1954, *The Crookedest Railroad in the World*. Theirs was a chronological history of the life of the railroad. This is a linear history about the path of the railroad. Most everyone who helped was a friend of Ted.

My deep thanks goes to two former scenic railway employees: Robert W. Smith, who lives today in Virginia and was a gravityman who kept colorful accounts in his journal of his short career on the mountain; and fireman Bill Provines, the last man who worked the engines on Mount Tamalpais. Provines remembers the people and the times of 80 years ago as though they happened last week. Ted's daughter Margaret Ridgway is a dynamo like her dad; she showed me the notes written to me in the tiny office where he had left them and the files of our collaborations. Paul C. Trimble, a five-time Arcadia veteran and enthusiastic rail historian, was of incalculable help. A seasoned writer and collaborator, Paul was invaluable as the clock ticked away. Thank you so much! To Marin historians and members of the Mount Tamalpais History Project: Pete Martin (amazing photographs and old newsletters), Nancy Skinner (photographs and files, too), Dewey Livingston (photographs and map), Brad Rippe, and Bill Sagar, thank you so much for your support. I cannot forget late members of the Mount Tamalpais History Project, including bohemian camper Phil Frank, Fred "I got something hot!" Sandrock, Lincoln Fairley, and Ted Wurm, who always had another story. To my great friend Arlene Halligan, collaborator on four mountain-wide centennial events in the past dozen years, your tenacity inspires everyone at the underfunded State Parks. Thanks also to the late great-grandson of Sidney Cushing, James Jenkins, and his friend, historian Richard Torney. Others I'd like to thank are historian and author Barry Spitz; George Harlan Jr.; Cris Chater, whose film *Steamy* really lit my fire; Tamalpais rangers Randy Hogue and Jim Vitek; Bob Brown at the *Narrow Gauge and Shortline Gazette*; Susan Snyder at the Bancroft Library at the University of California, Berkeley; Mia Monroe at Muir Woods; David Grossman and Jessica Ryan in the Lucretia Little History Room of the Mill Valley Library; Laurie Thompson in the Ann Kent Room in San Rafael; and ever-enthusiastic Kelly Brisbois, curator of education at the Marin History Museum. Support from Jeff Craemer and the Mount Tamalpais Interpretive Association (MTIA) has been invaluable. I'd also like to thank the contributions of photographs from the private collections of Barbara Dean Voisin, Sue Durkovich, Robert Rydjord, Frank Nicol, and Annabelle Marsh Piercy. Thanks also to the late great-grandson of Sidney Cushing, James Jenkins, and his friend, historian Richard Torney for their images.

Finally, for her unflinching support, lifting my spirits when they hit bottom, and having a vision that I too often lost, Merri Martori has been my rock, my companion, and my love.

INTRODUCTION

It is a pocket guide to a time that will never come again. A time when new rails were bringing Americans on steam trains to rustic places they had never been, to see wonders they had only read about.

Inspired by people like U.S. president Teddy Roosevelt and naturalist John Muir, Americans were going to see the scenic wonders of their country, places that were becoming national parks: the Grand Canyon, Yellowstone, Yosemite, and even Mount Tamalpais.

In 1903, President Roosevelt stood at the rim of the Grand Canyon and said, "Leave it as it is. You cannot improve on it. The ages have been at work on it, and man can only mar it. What you can do is to keep it for your children, your children's children, and for all who come after you, as one of the great sights which every American, if he can travel at all, should see."

Away from the noise and smell of America's early 20th-century cities, people could drink in the peace, quiet, and serenity of nature. Every one of them came well dressed. It is what people did when they took the train or whenever they traveled. Train fares made the adventure affordable to the masses in a way it had never been before. The railroads built lodges with spectacular views and served elegant food. Before television, radio, sports arenas, and even movies, this was substantial entertainment.

Mount Tamalpais came early to the list of scenic railways in 1896, one of the most scenically varied rides in the world. On most others the landscape was forests, rivers, and mountains. From Mount Tamalpais there was the close-by city of San Francisco, its bay, the distant Sierra Nevada Mountains, and a vast Pacific Ocean. There was the grand Tavern of Tamalpais, a place of dining and dancing. Then later came the trip to a "primeval canyon" called Muir Woods. And there were the unique gravity cars.

Today most of the old route is now a fire road through public lands. This is a linear history, a guide to the path that was once climbed by steam trains. There are maps and photographs and stories of how it all worked. All *you* need now is a little imagination and a bottle of water

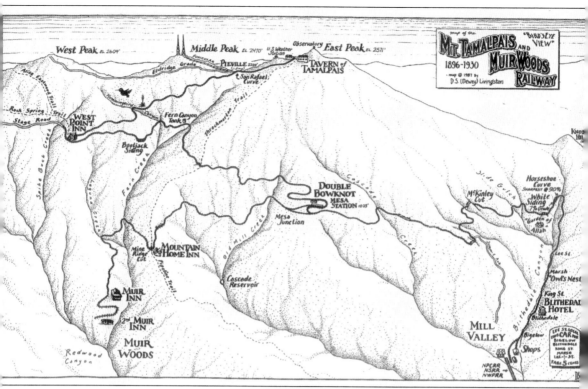

This map by Dewey Livingston shows the landmarks and the contours of the railroad on Mount Tamalpais. With 281 winding curves climbing 8.2 miles, from Mill Valley (right) to the summit at East Peak, it is easy to see why the scenic railway called itself the "Crookedest Railroad in the World." (Dewey Livingston collection.)

One

WHEN STEAM
CLIMBED THE MOUNTAIN

It was the most splendidly colorful time in Marin County's history, and it brought the tiny town of Mill Valley its first brush with international fame. For 34 years, from 1896 to 1930, a little steam railroad climbed from the hamlet of Mill Valley up a half mile of mountain to a grand lodge in the clouds. To get there was a travel adventure involving an eclectic mix of vehicles on water, rail (both steam and electric), and even gravity-powered transport. A stagecoach ride was an option too. It was 8.2 miles of winding railroad that became known as the "Crookedest Railroad in the World." The journey to the summit of Mount Tamalpais began at San Francisco's Ferry Building. A steam ferryboat and short train trip brought visitors to the quiet whistle-stop of Mill Valley, a town that still looks much the same today (except all the trains are gone). This chapter shows the beginning of the journey from San Francisco and the first half mile of the rails in Blithedale Canyon.

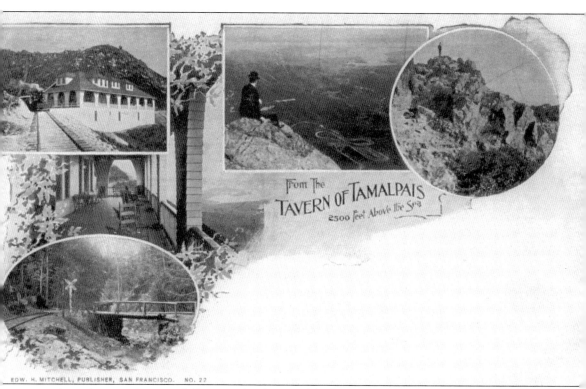

An early souvenir postcard illustrates the charms of the first years of the Crookedest Railroad. Steam drifts from the engine alongside the new Tavern of Tamalpais, a half mile above San Francisco Bay. There is a long porch where visitors could sit with a drink and contemplate the view of the biggest city in the West and the scale of humans against the vista. (Author's collection.)

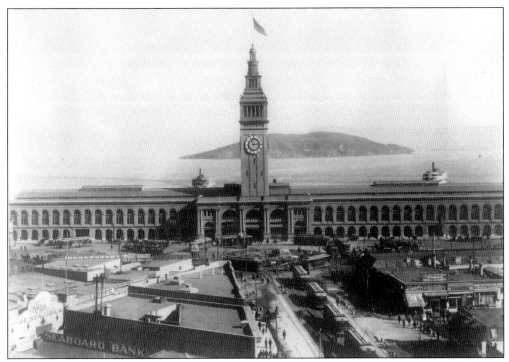

The San Francisco Ferry Building was the beginning of a two-hour trip to the summit of Mount Tamalpais. This was the second-busiest passenger terminal in the world after the Charing Cross Station in London, England. Fifty-five million people passed beneath the landmark clock tower each year during the 1920s and 1930s. (Paul C. Trimble collection.)

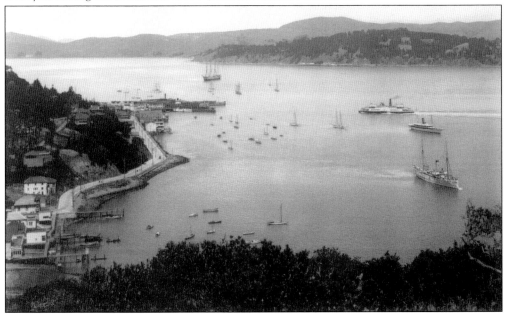

Steam-powered paddle wheel ferryboats sailed vigorously across the bay to the railhead at Sausalito. There, narrow-gauge steam trains and later all-electric interurban trains waited to whisk passengers along the waterfront to Mill Valley. (Ted Wurm collection.)

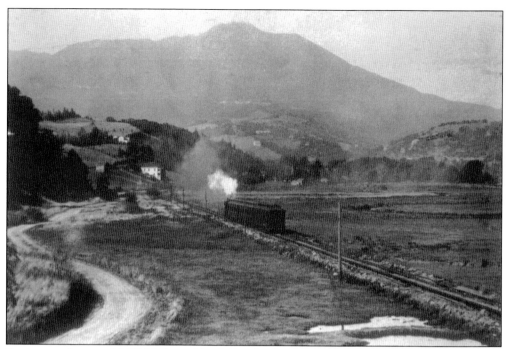

Racing north toward Mill Valley, a North Pacific Coast (NPC) passenger train hurdles across the wetlands of Richardson's Bay around 1900. In the years to come, Miller Avenue will be laid along the left side of the tracks, Tamalpais High School will be built where the camera stands, and decades after that a large supermarket and its parking lot will be built to the right of the tracks. (Martin/Jennings collection.)

Cascade Canyon, located at the foot of Mount Tamalpais and seen here around 1903, is less populated and wooded than today. The line across the mountain is the rising grade of the Mill Valley and Mount Tamalpais Scenic Railway. The destination is East Peak, the highest point on the mountain. (Martin/Jennings collection.)

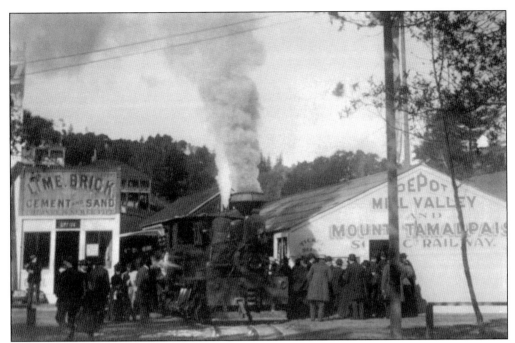

People mill about on Throckmorton Avenue next to one of the first trains up Mount Tamalpais, perhaps a special press train filled with newspapermen eager to see the sights and tell the story of the new railroad twisting along the ridges of Mount Tamalpais. Engine No. 498 waits at the first depot of the Mill Valley and Mount Tamalpais Scenic Railway, breathing smoke and steam into the summer sky. (Bancroft Library, University of California, Berkeley.)

Smoke curls from a train waiting at the platform of the Mill Valley depot. The first depot was not used for long. Passenger operations moved across Throckmorton Avenue and shared facilities on Miller Avenue with the NPC, the North Shore (1902), and finally the Northwestern Pacific Railroad (1907). The faint outlines of the Sausalito hills and San Francisco Bay are visible above the depot. (Martin/Jennings collection.)

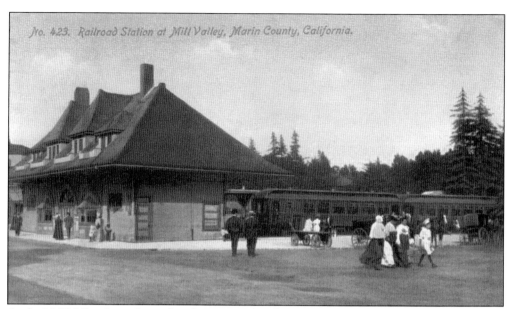

At the Mill Valley depot, located at the corner of Miller and Throckmorton Avenues, trains came and went from early morning to late at night. Mr. Marvin, the stationmaster, lived upstairs. He sold tickets and monitored train and passenger traffic and the Western Union telegraph downstairs. In the railroad era, this was the town center. People walked most everywhere. Trains connected Mill Valley to the world. (Author's collection.)

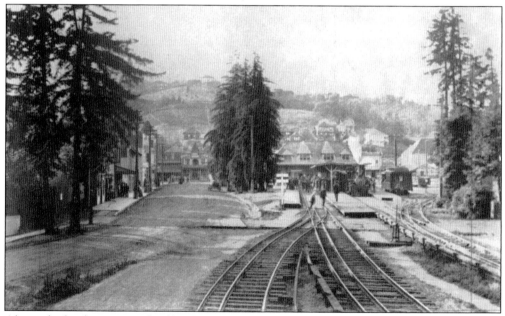

Alongside the dirt streets of Mill Valley is leading-edge rail technology, seen here around 1910. The North Shore Railroad catapulted southern Marin from quaint narrow-gauge steam trains to clean, quiet, standard-gauge electric rail service in 1903, the same year as New York City. The standard-gauge tracks are for interurban passenger service, while the narrow-gauge track is for freight. The electrified "third rail," located beneath the passenger platforms and cowling, carried 600 volts of direct current. (Lucretia Little History Room, Mill Valley Public Library.)

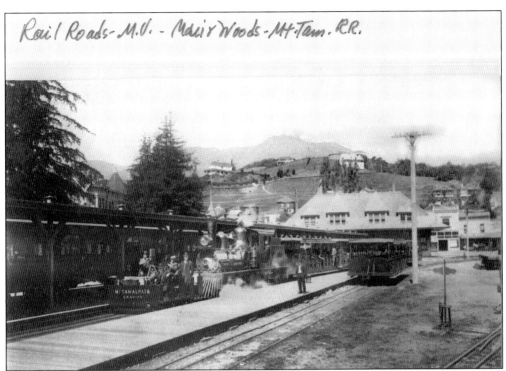

Early movies often showed intriguing destinations, and Mount Tamalpais certainly qualified. Thomas Edison's kinetoscope film crew shot possibly the first moving pictures in Marin County on Mount Tamalpais in March of 1898. The Miles Brothers (seen here around 1906) shot *A Trip Down Mount Tamalpais* with cameras mounted on a gravity car. Many of these films still exist in the Library of Congress. (Lucretia Little History Room, Mill Valley Public Library.)

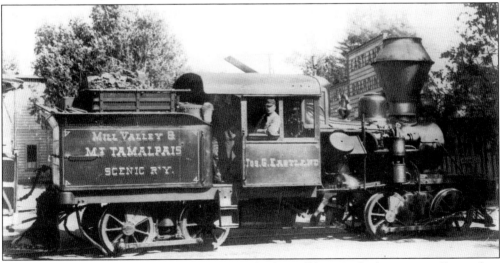

Engineer Ernest Thomas is in the cab of No. 2 ("The Bull"), a Heisler locomotive. Ernest (not Chester, as in some earlier histories) was the brother of gravity car inventor Bill Thomas and ran the first passenger train up Mount Tamalpais on August 22, 1896. On August 22, 1900, Ernie Thomas was scalded to death when No. 2 ran away and derailed; one of only two fatalities on the line. (Lucretia Little History Room, Mill Valley Public Library.)

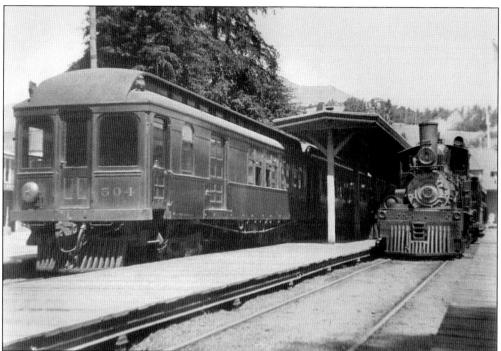

This is how easy and efficient train connections once were. When the electric interurban (left) rolled into the station at Mill Valley, travelers had three minutes to step from the train, walk across the wooden platform, and climb into the waiting open-air cars of the Mill Valley and Mount Tamalpais Scenic Railway, with the sturdy Shay and her crew ready to depart. (Ted Wurm collection.)

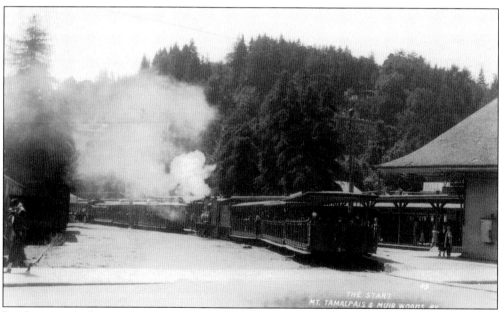

Ready to go on a busy morning in 1920, two 3-car trains are close to departure, their seats full of well-dressed passengers. In a few moments, the first engine's heavy brass bell will begin to clang, and the three open-air cars will begin to ease across Throckmorton Avenue. (Author's collection.)

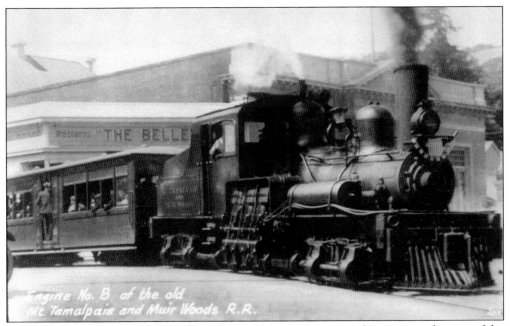

The bell of No. 8 peals from the middle of Throckmorton Avenue as the engine pushes one of the enclosed cars of the Crookedest Railroad. Looks like it might be a windy day up on the mountain. Enclosed cars like this one were open-air cars rebuilt and enclosed at the railroad's shops. Behind the locomotive is the same Bank of America that stands today. (Ted Wurm collection.)

In this *c.* 1904 image, the rails of the Crookedest Railroad begin their climb after emerging from between two buildings at right. They cross Lovell Avenue and run along the western edge of Corte Madera Avenue. Two men walk the mainline rails near the railroad's water tower. The other tracks are a siding where the engines take fuel and water each morning. In 30 years, Mill Valley's city hall will be in the trees on the left. (Ted Wurm collection.)

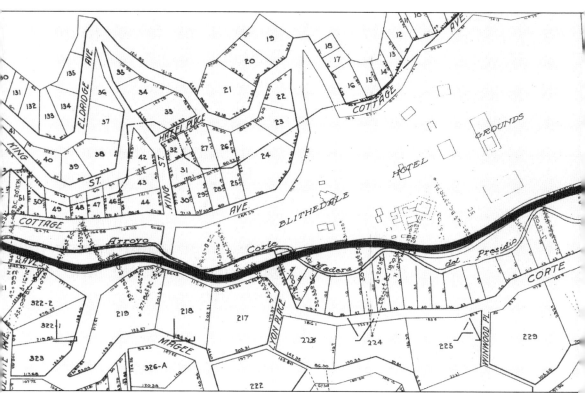

This detailed 1912 map uses a heavy black line to show the route from the depot (far right) up Blithedale Canyon. Tracks from the depot ran across Throckmorton Avenue, between the buildings, and up Corte Madera Avenue. Just past Lovell, the line crosses Corte Madera Avenue and runs past the shops (just below the word "Arroyo" on page 19). Note the switch and tracks into the shops. This is where the engines and cars spent the night. A few hundred feet farther

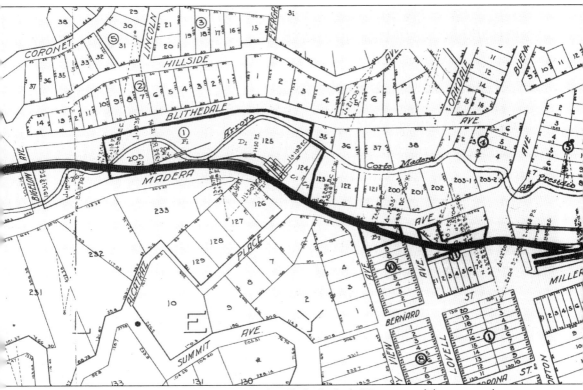

is another switch. This was for a storage track called "the hole." It is one of the easiest places to find the path of the old railroad through Blithedale Canyon and is known today as Miller Grove Park. Founding president Sidney Cushing's family-owned Blithedale Hotel (see page 27) was near the tracks, between the word "Hotel" and the heavy black line. (Bill Provines collection.)

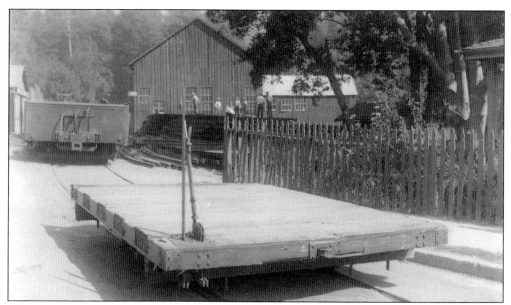

Taken during the scrapping of the Crookedest Railroad in 1930 (note the men standing atop a pile of scrapped rails), this is a rare photograph of the railroad shops, the large barn-like building in the background. This was the site of much of the maintenance work. Master mechanic (and later superintendent) Bill Thomas had his office there. Thomas invented the railroad's gravity car. In the foreground is a denuded gravity car used in scrapping. (Lucretia Little History Room, Mill Valley Public Library.)

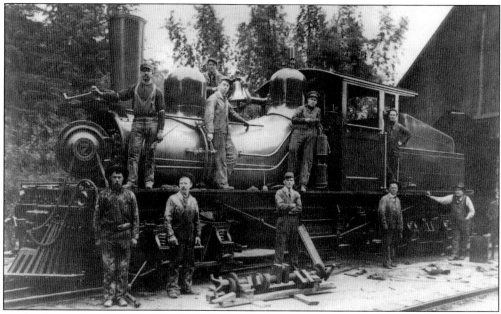

At the doorway of the shops, workmen prepare engine No. 7 for mountain work in 1908. When done, No. 7 will be taken to Double Bow Knot and be turned around on the "wye." The engine will spend her years on Mount Tamalpais working in the other direction. Beneath the cab, wearing greasy coveralls, a white shirt, tie, and bowler hat, is Bill Thomas, a well-respected, hands-on manager. (Howard Folker photograph; Ted Wurm collection.)

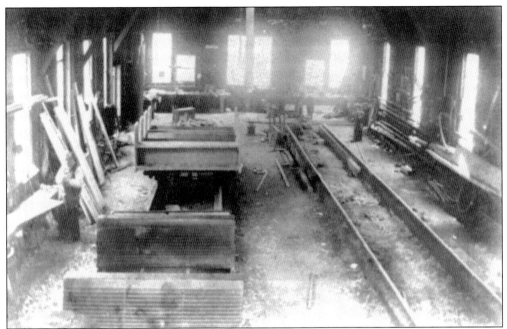

Here is the only known look inside the railway's shops, a self-contained facility of rebuilding, repair, and even the construction of new cars that include the first 10 gravity cars used on the line. The empty space filled quickly when a locomotive was in for repairs. Imagine the silhouette of a train moving past the windows, on the right along the mainline just outside the windows, as the ground trembles. (Howard Folker photograph; Ted Wurm collection.)

Looking out the door of the shops of the railroad into present-day Miller Grove Park, two men take a break while working on combo car (part open, part closed) No. 20. Between the two cars is the service pit, a slot in the ground between the rails that allowed shopmen to climb beneath a car or locomotive and stand while working. (Howard Folker photograph; Ted Wurm collection.)

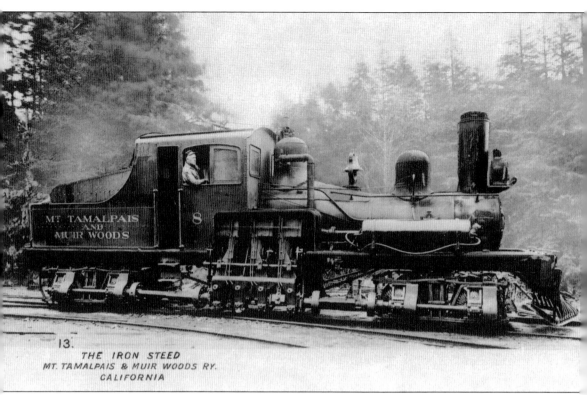

13.
THE IRON STEED
MT. TAMALPAIS & MUIR WOODS RY.
CALIFORNIA

A steep mountain railroad with lots of curves needed a special locomotive. The 8 Spot was 74,000 pounds of hardworking, standard-gauge steam locomotive. Shays had a geared driveshaft along their right side that put power to all the wheels, giving them an ability to climb hills most others could not. To balance the weight on the tracks, the Shay's boiler was offset to the left side on the fireman's side. (Author's collection.)

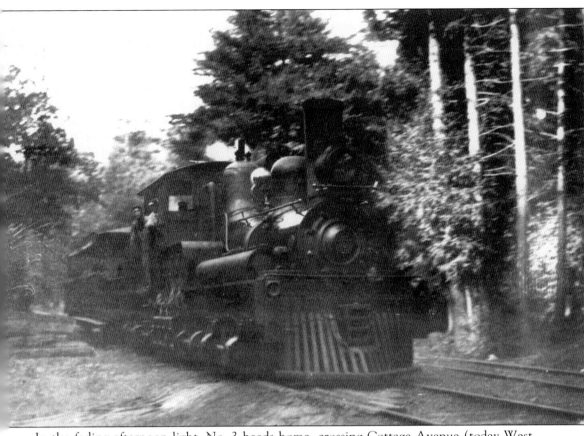

In the fading afternoon light, No. 3 heads home, crossing Cottage Avenue (today West Blithedale Avenue). The engine is at the south end of the two-track Lee Street Station. The second track was used for storage of passenger cars or gravity cars. (Howard Folker photograph; Ted Wurm collection.)

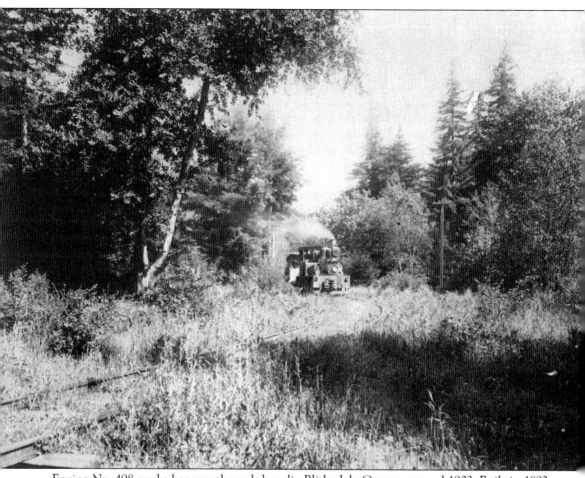

Engine No. 498 works her way through bucolic Blithedale Canyon around 1903. Built in 1893 by the Lima Locomotive Works in Ohio, she was displayed that same year at the World's Fair at Chicago's spectacular Columbian Exposition. She was the first locomotive on Mount Tamalpais, working with construction crews in 1896, and was sold in 1904, serving for at least five other railroads before being scrapped. (Ted Wurm collection.)

Two

PEOPLE MAKE A RAILROAD

For 34 years, Mill Valley's small privately owned railroad had international fame. Clever young businessmen built a steam railroad up a mountain and into a wilderness they enjoyed. They built lodges for overnight stays that had dining and dancing while musicians played. The Mill Valley and Mount Tamalpais Scenic Railway was constructed in six months, from Mill Valley to Mount Tamalpais's East Peak, using 8.19 miles of track to ascend a half mile of mountain. There were no less than 22 trestles and 281 curves along the way. All the curves, if connected, could have made 42 complete circles, an average of five per mile. It was a resourceful railroad, using gravity cars to bring passengers down the mountain at minimal cost and to add a great experience. The railroad brought new jobs to Mill Valley. Most of the employees lived in Mill Valley and walked to work. The railroad management consisted of business-minded conservationists. Sidney B. Cushing, the railroad's founding president, oversaw the railroad in its early years of clever elegance and success, the expansion of the popular Tavern, and the building of the West Point Inn, the stage road to Willow Camp, and the stylishly rustic Muir Woods complex. He was a close friend of William Kent. Kent and his wife, Elizabeth, gave Muir Woods to the United States in 1907, and Cushing witnessed the signing. William Kent was also one of three congressmen who created the National Park Service and campaigned heavily for the creation of the Marin Municipal Water District as a way to preserve the wilderness on Mount Tamalpais.

Other important people were mechanical genius Bill Thomas, the gravity car inventor; senior engineer Thomas "Jake" Johnson; and the railroad's last living fireman, Bill Provines, whose vivid memories inform this book.

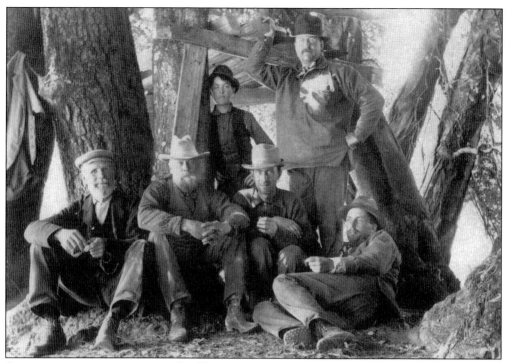

Some uncommon men at a ramshackle campsite were important to the Crookedest Railroad and Mount Tamalpais. From left to right are beaming naturalist John Muir; two unidentified people; progressive philanthropist and later congressman, William Kent; Kent's friend Sidney B. Cushing, the founding president of the Mill Valley and Mount Tamalpais Scenic Railway and owner of the San Rafael Gas and Electric Company; and Eugene DeSabla, cofounder of Marin's electric North Shore Railroad (1902) and PG&E (1905). (Lucretia Little History Room, Mill Valley Public Library.)

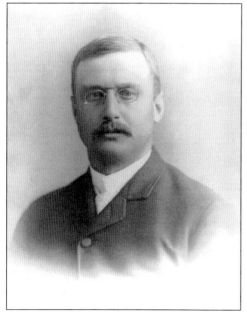

Sydney B. Cushing was the founding president of the Mill Valley and Mount Tamalpais Scenic Railway. He was a capitalist and a progressive conservationist who inspired William Kent. Kent dedicated the Mountain Theater to his late friend in June of 1915, saying Cushing "is the man who first taught me the lesson that this mountain is too good a thing to be reserved in the hands of a few." (Ted Wurm collection.)

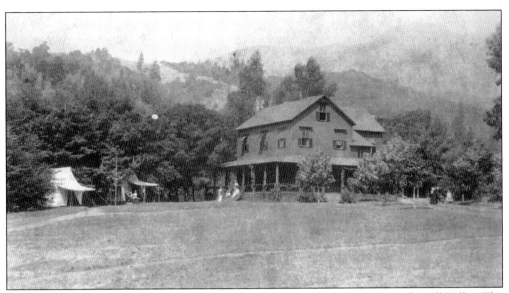

The Blithedale Hotel, owned by the Cushing family, was a popular resort in early Mill Valley. The Cushings hired professionals to run the hotel. Regular guests were from San Francisco society, including Mayor Adolph Sutro. The Blithedale Hotel gave the canyon and today's Blithedale Avenue their names. The wagon road from the North Pacific Coast rails to the hotel is today's Blithedale Avenue. (Martin/Jennings collection.)

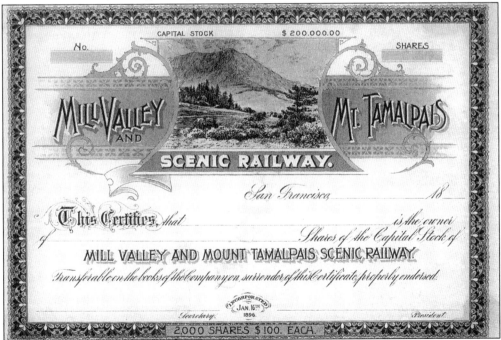

Stock certificates of the Mill Valley and Mount Tamalpais Scenic Railway were works of art. The railroad incorporated on January 16, 1896. The first corporate meeting was held on February 1; construction began four days later. A number of delays and hurdles had to be overcome as construction started, but on August 18, 1896, the last spike was driven at East Peak. Four days later, the first train brought passengers up Mount Tamalpais. (Al Graves collection.)

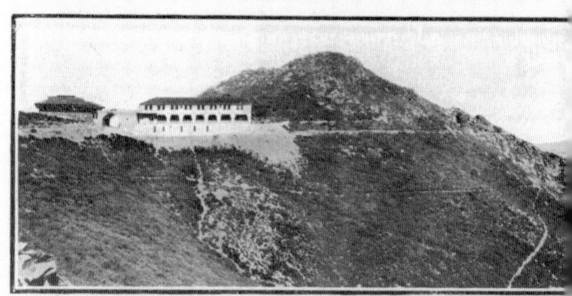

Tavern of Tamalpais. Mt. Tamalpais. Profile Rock. Point
(Elevation 2592 Feet.)

A panoramic c. 1900 postcard illustrates the multitude of things found on the "Mount Tamalpais Trip," including the Tavern and many famous landmarks. Contrary to what the postcard states, Mount Tamalpais's actual elevation is 2,571 feet. Of course, the railroad sold picture postcards. They could be postmarked "Tamalpais" and mailed by train from the Tavern to anywhere in the

ALPAIS SCENIC RAILWAY

nd. Berkeley. Oakland. Alameda. San Francisco. Pacific Ocean.
iablo. Tiburon. Belvedere. Double Bow Knot. Golden Gate.

country for only a penny and overseas for 2¢. Scores of inexpensive cards promoted highlights
and the guests' favorite part of the trip. (More post office information can be found on page 85).
Also note the level trail running to the right from the Tavern. Known then as the Racetrack
Trail, today it is referred to as the Verna Dunshee Trail (see page 90). (Author's collection.)

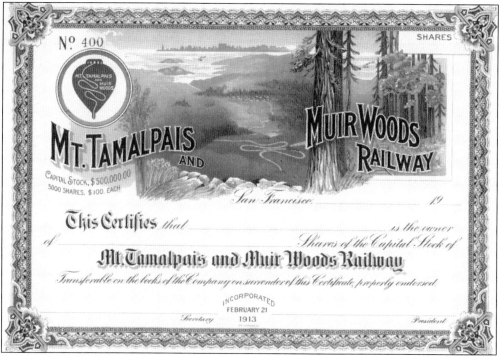

No 400 SHARES

MT. TAMALPAIS AND MUIR WOODS RAILWAY

CAPITAL STOCK, $500,000.00
5000 SHARES. $100. EACH

San Francisco, 19

This Certifies that _____ is the owner
of _____ Shares of the Capital Stock of

Mt. Tamalpais and Muir Woods Railway

Transferable on the books of the Company on surrender of this Certificate, properly endorsed.

INCORPORATED
FEBRUARY 21
1913

Secretary President

In 1913, the railroad reorganized, changing its name partly to reflect the success of the new branch line to Muir Woods and also to raise capital to buy new equipment and repair the line for San Francisco's upcoming World's Fair, the spectacular 1915 Panama-Pacific International Exposition. The year 1915 was, in fact, the railroad's busiest, averaging 700 passengers a day during the summer months; and parking in Mill Valley was never a problem. (Author's collection.)

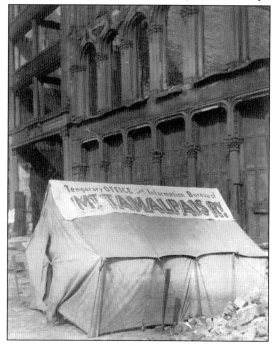

The new railroad responded well to challenges, such as creating a temporary tent office in the rubble of the 1906 earthquake. The railway itself suffered little damage. Days after the quake researchers rode the Crookedest Railroad to West Point, recorded that neither the inn nor the Tavern suffered significant damage, and took the stagecoach to Bolinas. The man who named the San Andreas Fault, renowned geologist Andrew C. Lawson, supervised the report. (Ted Wurm collection.)

The only California "competition" for Mount Tamalpais was a scenic railway near Pasadena known as Mount Lowe. Mount Lowe offered a white-knuckle ride up a long 62 percent incline, then a trolley ride along sheer cliffs to the Alpine Lodge where the tracks ended. Mount Tamalpais was gentler ride up a grade that was typically 5 percent and slightly over 7 percent in spots. Mount Lowe Railway ran from 1893 to 1937. (Author's collection.)

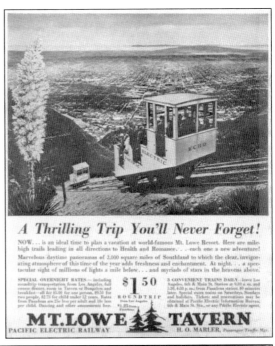

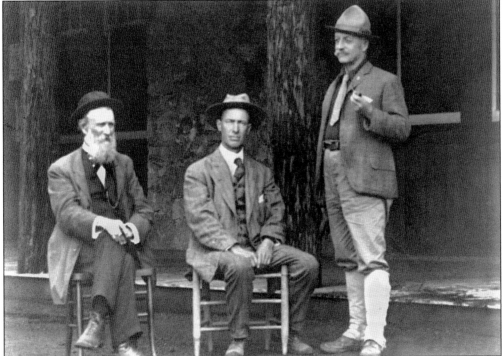

On January 9, 1908, Muir Woods became the United States' 10th national monument, a gift to the country from William and Elizabeth Kent. Kent (center) felt it was important to honor John Muir (left), who through his eloquent writings showed America that nature was for more than just harvesting. Gifford Pinchot (right), the head of the U.S. Forest Service from 1905 to 1910, helped to broker the deal with Pres. Teddy Roosevelt. (Nancy Skinner collection.)

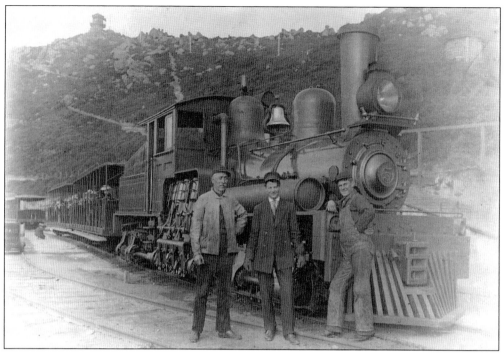

Senior engineer Jake Johnson (left) delivered the first engine to Mount Tamalpais and stayed for 34 years. Fireman Bill Provines recalled Johnson as a quiet gentleman of great skill. "Very professional, never said a word except at lunch or while waiting at East Peak. Prior to departure he was all business. He knew the railroad like the back of his hand." Jake, Cliff Graves, Wesley Armanger, and No. 5 pose here at East Peak around 1907. (Bancroft Library, University of California, Berkeley.)

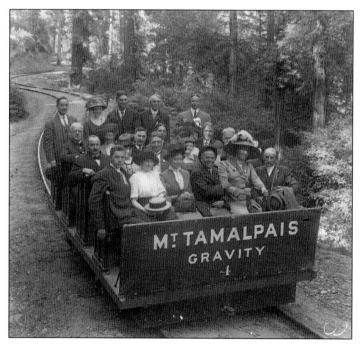

Gravity car inventor and master mechanic Bill Thomas, seen here in the front row with the bowler hat in 1911, loved to show Mount Tamalpais to the railroad's passengers. He would describe the scenic wonders of the mountain or sometimes lead them in patriotic song while waiting for a connection at Mesa Station. One of Thomas's favorite songs was "America the Beautiful," its words written by Katherine Lee Bates, who was inspired by the purple mountains majesty she saw riding on another scenic railway to Colorado's Pike's Peak. (Author's collection.)

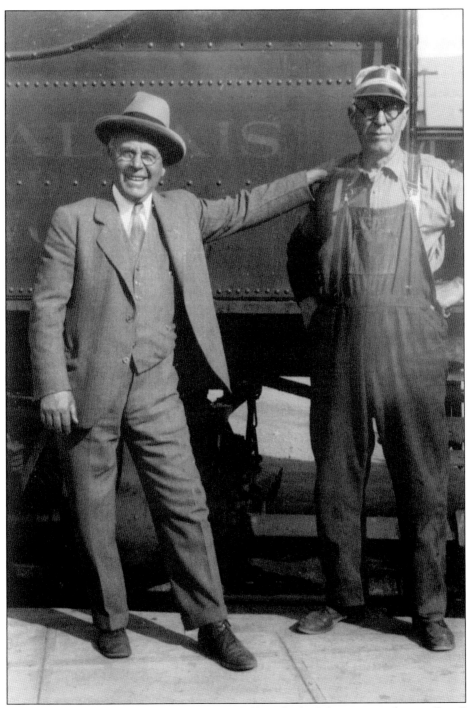

Longtime friends and colleagues Bill Thomas (left) and Jake Johnson, seen here at East Peak around 1929, worked together during most of the scenic railway's lifetime. Thomas was an inventive mechanical genius with a sense of humor. Always well dressed, Thomas was never afraid to climb into the cab to fix something. Notice he wears practical work shoes. In his retirement, the ever-smiling Bill Thomas said, "I never worked a day in my life." (Dewey Livingston collection.)

Perhaps the most unique experience on Mount Tamalpais's scenic railway was a ride in the gravity cars, coasters invented in 1902 by Bill Thomas. This is a great example of an early six-person "gravity." The novel coaches became a big hit, and Mount Tamalpais advertised itself as "the world's longest rollercoaster." A "gravityman" was often a guide for the passengers. This gravityman (second from the left) is George Turner Marsh, a railroad stockholder. (Annabelle Marsh Piercy collection.)

Three illustrations (from left to right c. 1903, 1912, and 1927) show the evolution of the railroad's emblem. The reference to a toy top suggests Mount Tamalpais "is tops." The crown of the top has the scalloped archways of the first Tavern of Tamalpais. The weaving line represented the Double Bow Knot, an engineering achievement and landmark the scenic railway was proud of. As time passed, the logo became busier. (All author's collection.)

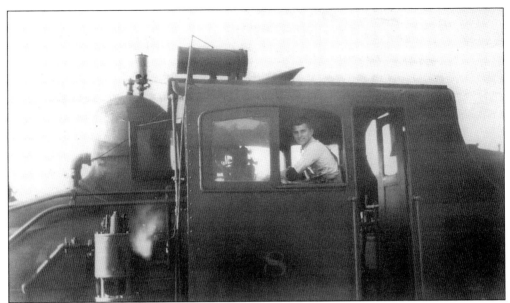

Bill Provines, age 19, smiles from the fireman's side of engine No. 8 as he waits for the next run from the summit in September of 1928. Provines worked the last three years the railroad ran, from 1926 to 1929, sometimes working several jobs in one day. The job he loved best and did the most was fireman, tending the boiler in the hot noisy cab of the Shay engines. Today, 80 years later, Provines's vivid memory is an important link to the days of the scenic railway. (Author's collection.)

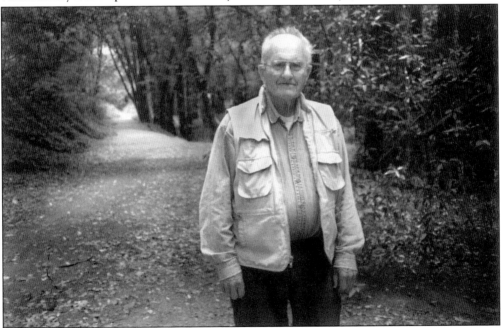

With the path of the old railroad disappearing into the trees of Miller Grove Park, Bill Provines stands at the spot where he first worked for the mountain railroad on July 12, 1926. Engine No. 4 was parked here at the door of the railroad's shops facility. Provines climbed aboard and had one trip up Mount Tamalpais to learn the complicated job of fireman. "It was the best job I ever had," he said. (Author's collection.)

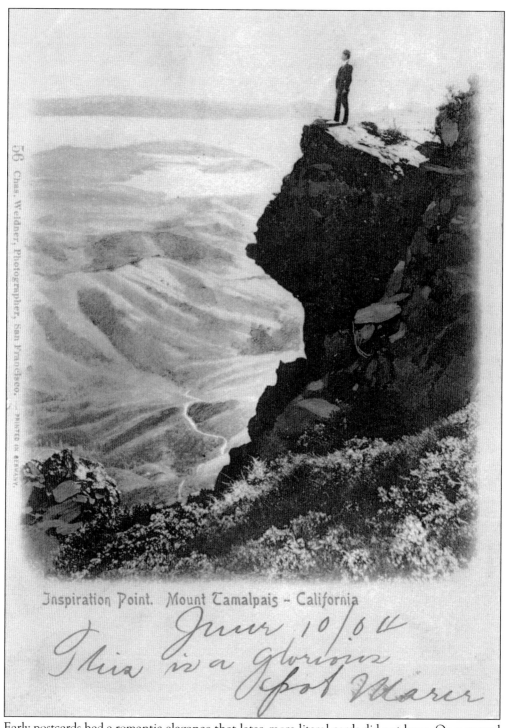

Inspiration Point. Mount Tamalpais ~ California

June 10/04

This is a glorious spot Marie

Early postcards had a romantic elegance that later, more literal cards did not have. On a rugged rock outcropping a man inhales inspiration from the grand view to San Francisco. This 1904 postcard from Mount Tamalpais was addressed to Hoboken, New Jersey, and reads, "This is a glorious spot." (Author's collection.)

Three

MARSH, LEE STREET, AND THE LOCAL

The north end of Blithedale Canyon, just before Lee Street, was the last gentle grade of the mountain railroad. A diminutive train, consisting of a small, steam engine and a lone passenger car, offered local service throughout the canyon. It was known affectionately as the Lee Street Local. "The Local" carried people about a mile up and down Blithedale Canyon all day long, making five stops along the way. Here is a look at Marin's only streetcar-type service, one of its stops, at the Japanese-styled estate of George Turner Marsh, and the last gentle grade before climbing the mountain from the Lee Street Station.

Engine No. 3 rolls through Blithedale Canyon on its way to the depot, an easy hiss from the air brakes as she coasts past, the bell clanging as crossings approach. Barely visible in the background is the Japanese-built gate to George Turner Marsh's estate "Miyajima" (Owl's Nest), a stop for the Lee Street Local. (Bancroft Library, University of California, Berkeley.)

On the left is the gate to the Miyajima estate, George Turner Marsh's summer home, built from pieces of the Japanese village he constructed for San Francisco's 1894 Midwinter Fair. Marsh's San Francisco residence was in "the Avenues" of San Francisco in an area he christened "the Richmond District" after his hometown in Australia. The narrow dirt road alongside the track is Cottage Avenue, known today as West Blithedale Avenue. (Howard Folker photograph; Ted Wurm collection.)

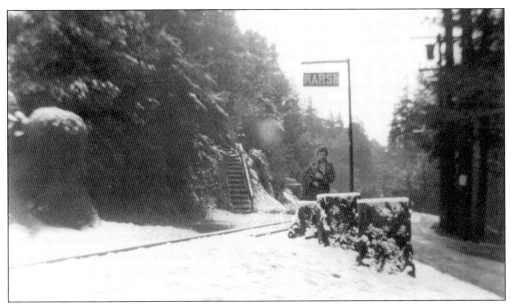

This photograph's notes say this is Minnie Feeney at the Marsh Station on January 22, 1922. The stop was no longer marked by a Japanese gate but now by a metal sign. Blithedale Canyon looks more familiar, even with the rare snowfall. The sign was at the corner of Marguerite and West Blithedale Avenues. The stairs beyond Feeney are at 360 West Blithedale Avenue, a spot that today is overgrown and buried in leaves and branches. (Lucretia Little History Room, Mill Valley Public Library.)

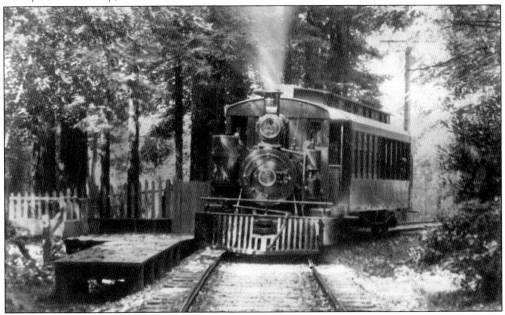

Small wooden platforms along the tracks marked the stops for the Lee Street Local. Like the mountain trains, the Local never turned around. The engine pushed from the depot to Lee Street and pulled back to the depot. "The Dinky" carried the citizens of Blithedale Canyon from 1906 to 1915 but was replaced by a more efficient gasoline powered Kissle Kar in an attempt to make the run profitable. (Dewey Livingston collection.)

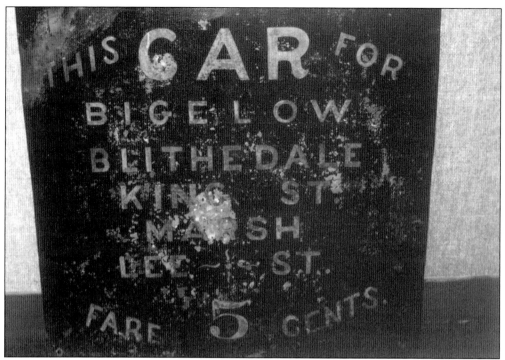

A hand-painted sign that hung aboard the Lee Street Local illustrates some changes since the early days in Mill Valley: Bigelow Avenue became Eldridge Avenue; the Blithedale Hotel was sold (1912) and streets subdivided its lands. The King Street stop (at Corte Madera Avenue) is a gravel parking pad today, and "Marsh," the estate of George Turner Marsh, is now Blithedale Park. The fare on the Lee Street Local was a reasonable 5¢. (Dewey Livingston collection.)

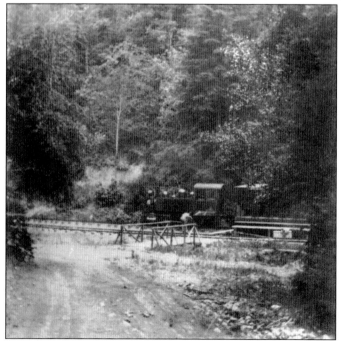

Footprints in the dirt of Lee Street lead to a rustic footbridge and the Lee Street Station. No. 6 waits for its next run to the depot. The little engine and its combo passenger car made 18 round-trips a day (around 1910) to the Mill Valley depot and back, providing the only streetcar-style service in Marin County. Canyon residents loved the red-maroon engine and called it The Dinky. (Ted Wurm collection.)

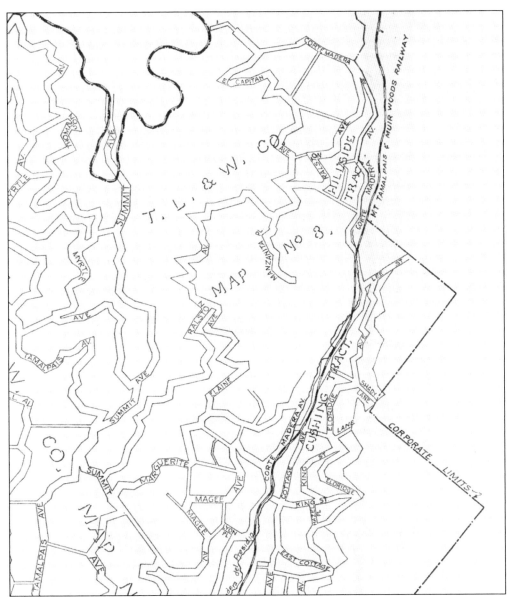

This *c.* 1915 map shows the northernmost streets and rails in Blithedale Canyon. King Street and Corte Madera Avenue made up a stop for the Lee Street Local. "Marsh" is where Marguerite Avenue meets Cottage Avenue (later West Blithedale Avenue). The Lee Street Station is at the foot of Lee Street. The wandering line at the upper left is both the city limits and the tracks of the Crookedest Railroad. (Author's collection.)

41

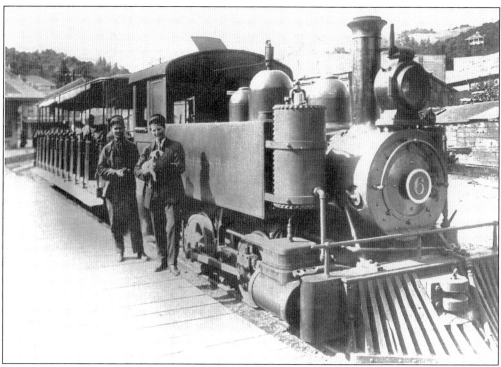

Public transit was once very coordinated. The trip from Lee Street to the depot took eight minutes, arriving at the depot three minutes before the interurban trains left for San Francisco. The trip to the city included stops in Mill Valley and Sausalito before a half-hour ferry ride. Total time from Lee Street to the Ferry Building was exactly one hour. Engineer Bonner Whitcomb and conductor Cliff Graves take a short break at the depot. (Ted Wurm collection.)

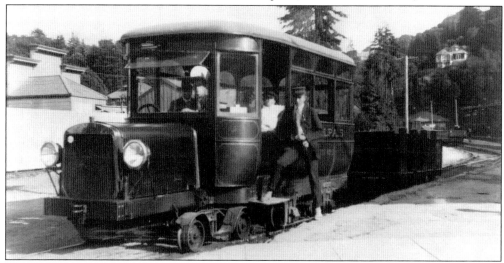

Custom built in San Francisco, the gas-powered Kissle Kar was the most elegantly appointed vehicle on the line, sometimes taking private parties to the Tavern. She was also temperamental, burning through three unreliable engines in nine years and often refusing to start on cold mornings. The Kissle Kar's engineer was also the conductor. A small turntable was added at Lee Street to turn her around. She could carry 20 passengers. (Ted Wurm collection.)

Four

BRIDGE 7 AND BEYOND

At Bridge 7, the grade became steeper, now climbing along the canyon wall, rising higher and away from the creek. The engine worked harder, laboring as it pushed the train higher. This part of the old grade was the last piece to become public land. It was punished by the torrential rains of El Niño in 1982, washing a big gouge out of the horseshoe turn at the north end of the canyon. Around 1910, gravity cars had orders to come to a stop at Bridge 7, just before the blind crossing of Corte Avenue (today West Blithedale Avenue). As automobile traffic increased in the canyon, it became harder for gravity cars to coast safely along because their warning bell (see page 68) was not loud enough to be heard above an automobile's engine. Above Horseshoe Curve, the grade climbed above the trees of Blithedale Canyon and passengers got their first glimpse of San Francisco and soon after a glimpse of the top of the mountain.

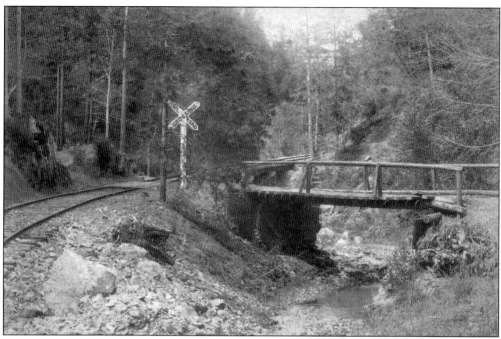

Saving the Northridge

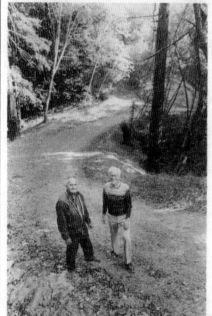

(Above) Author Ted Wurm and railroader Bill Provines at Horseshoe Curve at the upper end of Blithedale Canyon. Mush Emmons photograph.(Above right) Horseshoe Curve circa 1900 during the railroad's glory days. Photograph courtesy "Crookedest Railroad in the World."

Winning windows

The winners of the Homecoming Window Display Contest sponsored by the Tam Boosters were as follows: Grand Prize—Peaches and Cream; First Prize—Rethreads; Spirit Award—Lockwoods Pharmacy. Honorable Mention: Toy Mill, Dowd's Moving and Storage, Varney's Hardware, and Bay Tree Books.

Fireman Bill Provines calls Bridge 7 "the moment of truth." Just across the bridge the grade became steeper. "If you didn't have your stuff together, the engine would stall on the grade ahead." For Provines, the embarrassment would be absolute humiliation. "You'd never hear the end of it from the others." He never suffered that disgrace. Bridge 7, seen here around 1898, was the seventh bridge crossed by trains after leaving the depot. (Martin/Jennings collection.)

All but the first mile of the old railroad grade winds through public lands. In the early 1980s, developers wanted to build homes north of Bridge 7. In 1983, railroad historian Ted Wurm and mountain railroad fireman Bill Provines joined a consortium of small Mill Valley companies, town citizens, and city politicians. They raised money to buy the grade and give it to the newly formed Marin Open Space District. (Mill Valley Record, Mush Emmonds photograph; Ted Wurm collection.)

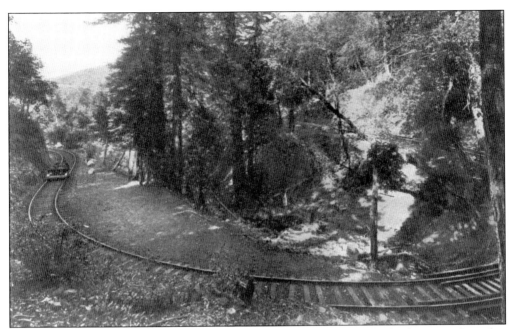

These two photographs show where the tracks changed their northerly climb, swung through a 182-degree arc at Horseshoe Curve, and climbed west along the southern face of Mount Tamalpais. Master mechanic Bill Thomas told his engine crews that at this sharp turn they became part of the scenery. The passengers on the lead car could look across Blithedale Canyon and see the crew in the laboring engine, pushing them higher. (Dewey Livingston collection.)

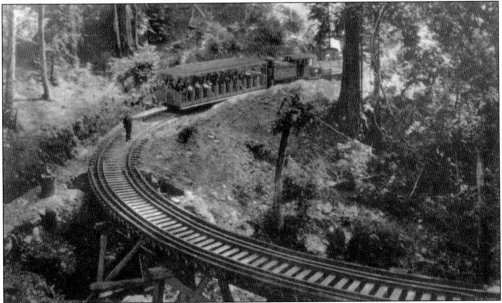

The climb from Bridge 7 to the summit was constant, even across the trestles. The grade averaged 5 percent as it scaled the contours of Mount Tamalpais. Supervising construction engineer George M. Dodge had to make the grade steep enough to reach the East Peak summit but not so steep the engine's polished steel wheels would lose traction on the shiny rails of the Crookedest Railroad. (Martin/Jennings collection.)

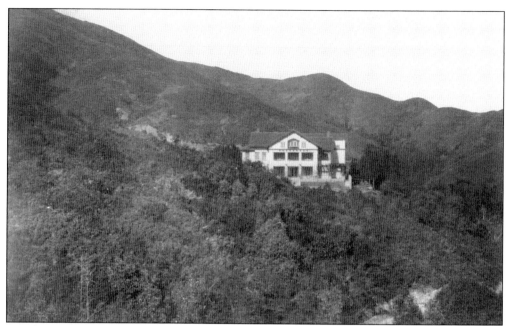

Just above Horseshoe Curve was a spot called White's Siding, a switch and a short piece of track where flatcars full of supplies (steel beams, terra-cotta roof tiles, and sacks of concrete) were stored during construction of Ralston White's "Garden of Allah." The railroad made moving those heavy supplies easy, and the steel and concrete enabled the building to survive the 1929 fire. McKinley Cut, a landmark on the railroad grade, is visible behind the mansion. (Lucretia Little History Room, Mill Valley Public Library.)

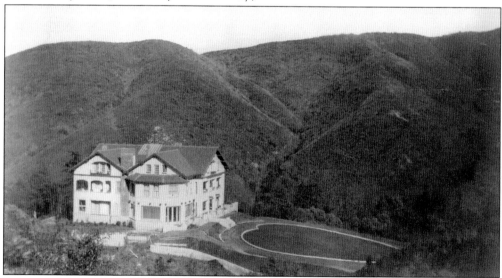

Ralston White's "Garden of Allah" (completed in 1915) was designed by Willis Polk. Polk began his career locally working with A. Page Brown, the designer of San Francisco's Ferry Building. Polk was the supervising architect of San Francisco's spectacular 1915 World's Fair, the Flood Mansion on Nob Hill, and the Carolands Chateau, an impressive Beau-Arts palace created for the heiress to the Pullman railcar fortune in San Mateo County. (Lucretia Little History Room, Mill Valley Public Library.)

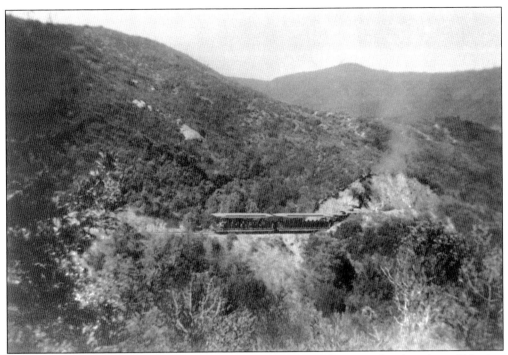

McKinley Cut was carved by hand during construction in 1896 using picks, shovels, and blasting powder on the solid rock of Mount Tamalpais. The cut was a nameless feature until 1901, when U.S. president William McKinley planned a visit. A hand-painted sign on the rock at the lower opening of the cut identified the spot for passengers. These days this end of the rock is overgrown, and the sign is hard to find. (Ted Wurm collection.)

On May 8, 1901, the 25th president of the United States, William McKinley, expected to ride the Crookedest Railroad up Mount Tamalpais. The railroad was eager to honor the president, building a flower-covered arch above the track and naming a landmark on the railroad for him. McKinley's wife, Ida, was sick that day, and the president cancelled the trip. (Ted Wurm collection.)

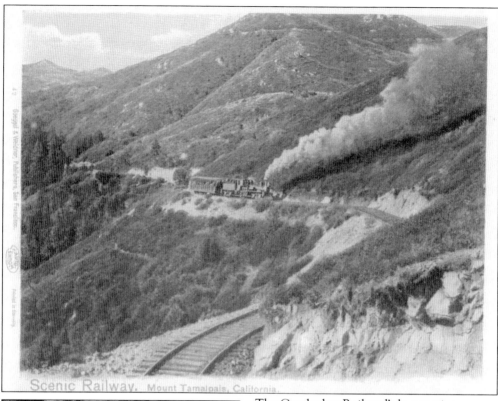

Scenic Railway, Mount Tamalpais, California.

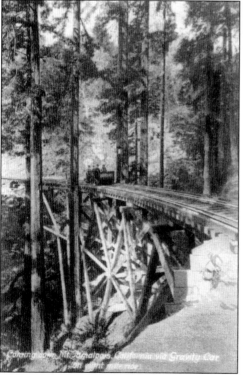

Coming down Mt. Tamalpais, California via Gravity Car

The Crookedest Railroad's locomotives always worked in the same direction: pushing backward uphill or leading the train down. They were never turned around. Putting the engine below the passengers guaranteed their cars would never break loose. It also meant that as the engine worked its hardest, climbing the mountain, the exhaust never rained down on the paying customers. (Author's collection.)

The first gravity car was created in 1902 as an inexpensive way to bring overnight guests from the Tavern to Mill Valley for a morning commute train to the city. A gravity car left the Tavern each morning at 7:20, coasting down the mountain as the sun rose above the East Bay hills. After a brief connection at the Mill Valley depot, travelers arrived in San Francisco at 9:05 a.m. (Ted Wurm collection.)

The Mount Tamalpais Scenic Railway boasted 22 trestles between Mill Valley and the summit, with 15 of them on the mountain's slope. Trestles flew up as the workers hand-built the grade in 1896 in a manner similar to trestles built 30 years before on the Transcontinental Railroad. (Martin/Jennings collection.)

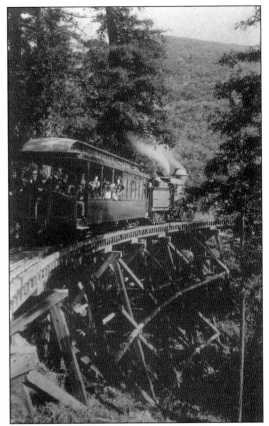

Bill Thomas (center) saved the railroad money in many ways. To cut maintenance costs, wooden trestles were bypassed, and the rails ran on fill that would not rot. The Old Railroad Grade, now a fire road, still uses filled culverts. In 1982, when El Niño thrashed Marin County, a number of these fills washed out, and the old trestle timbers were revealed. (Ted Wurm collection.)

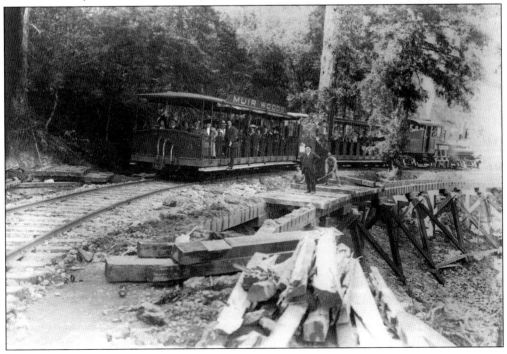

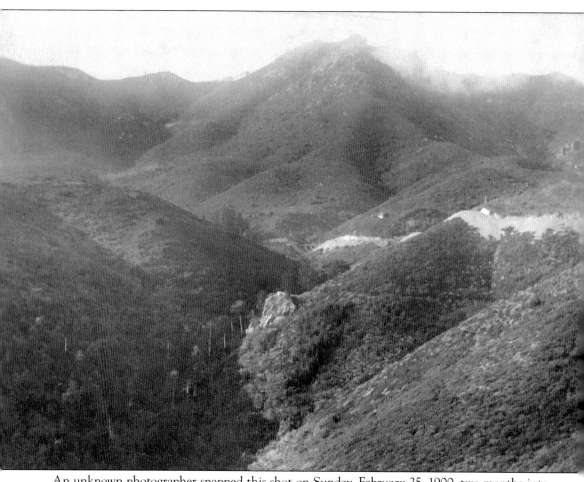

An unknown photographer snapped this shot on Sunday, February 25, 1900, two months into the 20th century. His view presents the past and the future, a wilderness that will be preserved and a railroad grade (middle right) for steam engines that will become obsolete. The future came to this mountainside two years earlier when, in 1898, Thomas Edison's kinetoscope film crew photographed what are likely the first motion pictures shot in Marin County (on the grade at right, with steam trains). The day after this photograph was taken, a construction crew will be at work up near the cloudy peak, expanding the second floor of the railroad's popular Tavern of Tamalpais. (Author's collection.)

Five

THE DOUBLE BOW KNOT

The crookedest part of the Crookedest Railroad was a clever bit of engineering, built on an ancient landslide across a broad ridge with a gentle slope. As civil engineer George M. Dodge and his party marked out the footpath the graders would follow up the mountainside, Dodge noted the climb to the West Point ridge was a steeper incline than he wanted. The design of the Double Bow Knot solved the problem. It came to him one night as he was drifting off to sleep. On the old landslide he could bend the track back and forth, creating a longer, easier grade, gaining elevation as the tracks ascended over the broad ridge. It would give him the altitude he needed without forcing the grade to be steeper than five percent. His daughter Mabel D. Bullis recalled her father's first meeting with the railroad's founding president, "I do remember Mr. Cushing talking to my father about the idea of a railroad up Mount Tamalpais and my father's great interest and excitement. The Double Bow Knot was his idea. And as you know, it became the trademark of the railroad" (see page 34). The Double Bow Knot just happened to be built at the midpoint of the railroad. The name, of course, was inspired by its resemblance to a loosely tied old-fashioned bow tie. Over the years, it became more than a picturesque marvel of engineering, the track looping back and forth five times on the mountainside through the tightest curves to gain elevation (130 feet) in a compact spot on the mountainside. By mid-1907, there would be a branch from the Double Bow Knot to Muir Woods, and the siding would become Mesa Station, a key station to transfer passengers. Panoramic souvenir photographs were taken on the lowest loop of the Double Bow Knot, showing the whole complex with the Tavern high in the background. Today it is interesting to walk through the Double Bow Knot, looking at the cuts made by the railroad in the old landslide, and the crumbling remnants of the Mesa Station platform.

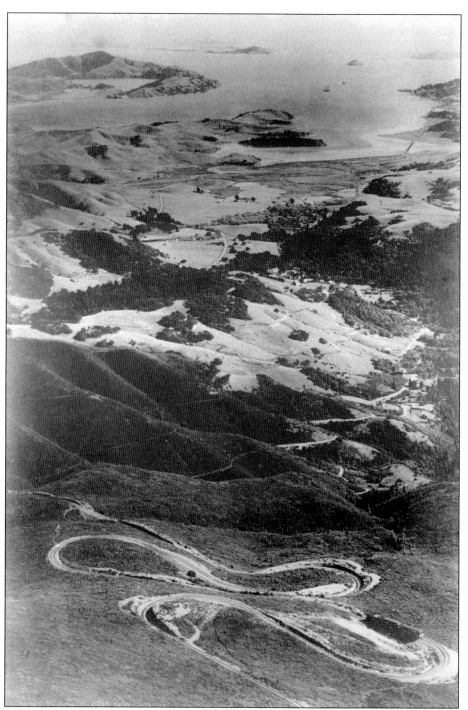

This is the Double Bow Knot around 1898. A lone train is at the western end of the longest straightaway on the railroad, measuring 413 feet, right smack in the middle of the Double Bow Knot. Also visible is the siding at Mesa (used for car storage that would later become a station) and the first structure, a small shed. Mill Valley lies below with San Francisco in the distance. (Ted Wurm collection.)

SCIENTIFIC AMERICAN

[Entered at the Post Office of New York, N. Y., as Second Class Matter. Copyright, 1898, by Munn & Co.]

A WEEKLY JOURNAL OF PRACTICAL INFORMATION, ART, SCIENCE, MECHANICS CHEMISTRY, AND MANUFACTURES.

Vol. LXXIX.—No. 3.
Established 1845.

NEW YORK, JULY 16, 1898.

[$3.00 A YEAR.
Weekly.

1.—A TYPICAL CURVE AND TRESTLE.

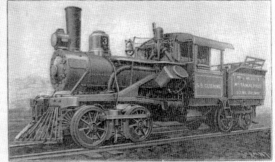

2.—30-TON GEARED ENGINE WITH TWO TRUCKS.

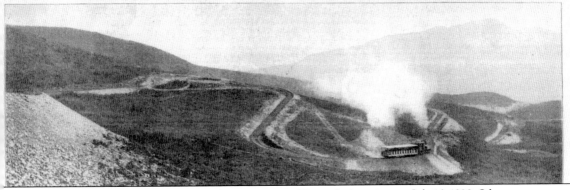

Mount Tamalpais's scenic railway was the cover story of *Scientific American* on July 16, 1898. Of course, engineering was the story. George Dodge supplied a list of facts, and the editors were impressed. The railroad must have sent the photographs. The cover had some embellishments. The *Marin Journal* noted the prestigious attention on July 28, 1898. Note the trains depicted on the Double Bow Knot, both here and on the previous page, are at the same spot. (Author's collection.)

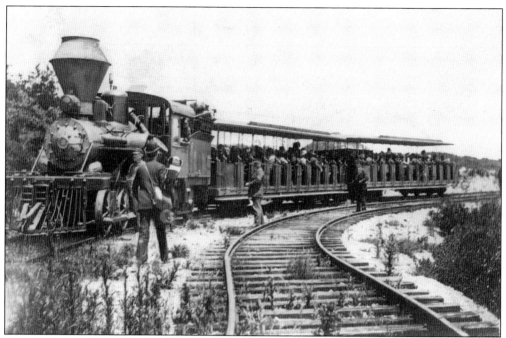

This 1898 view shows Mesa Station before a station and water tanks were built. This relatively level spot at the midpoint was a good place for a siding on a single-track railroad, a fine spot to pull off to let the opposing train pass. Later this would become an important transfer station for those bound for Muir Woods. A small shed stored some supplies and a telephone connected to the Tavern. (Lucretia Little History Room, Mill Valley Public Library.)

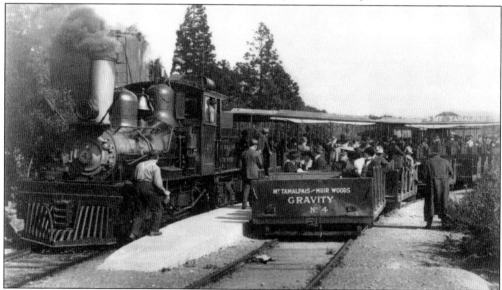

Taken at almost the same spot as the above photograph, this is how Mesa Station looked in the 1920s. Trees had grown on the semiarid mountainside thanks, in part, to water trickling from the railroad's water tanks. The water was used to cool and quiet the steel rail wheels on the track, and steam vapor clung to pine needles. The mainline track is overgrown today. The fire road uses the siding. (Graves Collection, Bancroft Library, University of California, Berkeley.)

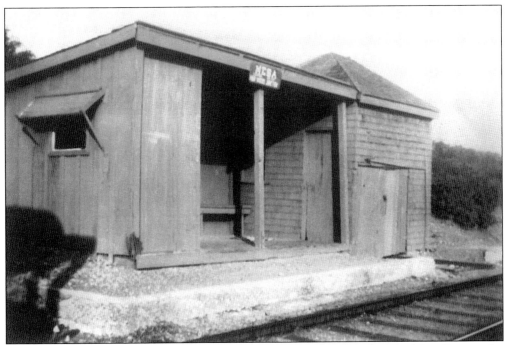

This c. 1928 image is the only known photograph of the small shelter that was Mesa Station. An open bench seat had some protection from the elements. At the left end was a small locked room. Inside an old crank telephone could be used for calling the Tavern or the offices in Mill Valley for new orders. Today the foundations are all that remain. (Bob Smith photograph.)

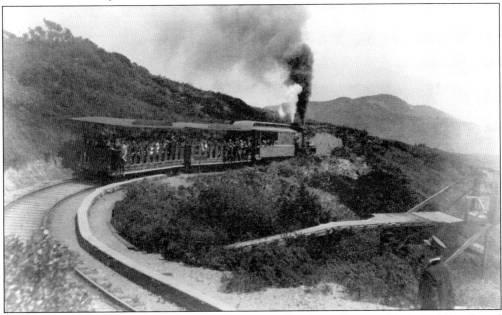

At the lowest level of the Double Bow Knot, just below Mesa Station, T. C. Wohlbruck and Company shot countless hundreds of souvenir panoramic photographs for passengers in the 1910s and early 1920s. He set his camera on a flimsy wooden platform built in the scrub brush. A nearby a metal sign stated, "Entering Double Bow Knot." (Author's collection.)

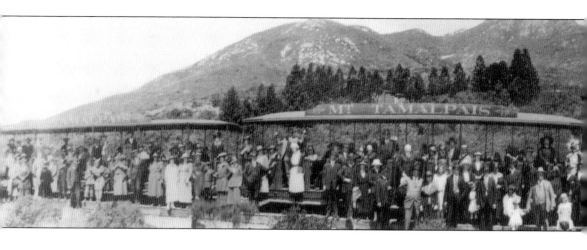

The T. C. Wohlbruck Company photographs are a great record of the times, including each working train and its passengers and crew. High in the background is the Tavern. Wohlbruck collected $1 from interested passengers, gave them a claim check, and returned to his panoramic camera to snap the photograph. Theodore Clemens Wohlbruck was an enterprising man who brought

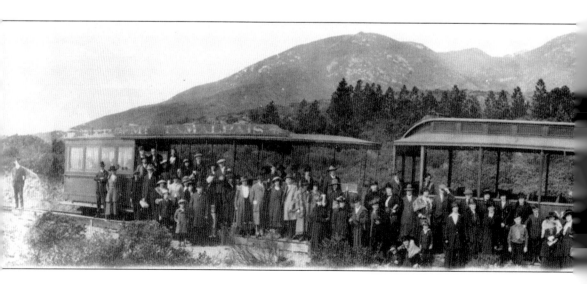

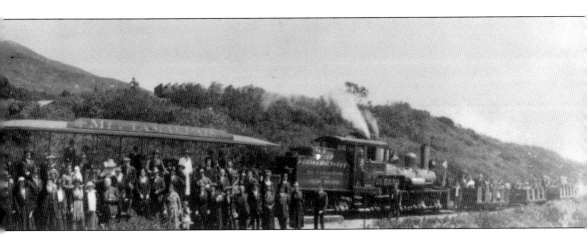

his panoramic photography business west from Massachusetts. Around 1918, Wohlbruck sold his bowknot business to "Headley," who copied Wohlbruck's style and shot panoramic photographs into the early 1920s. Both photographs are by "Headley." Note the gravity cars being towed back to the summit. (Ted Wurm collection.)

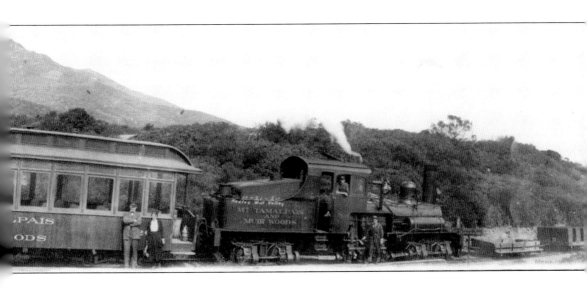

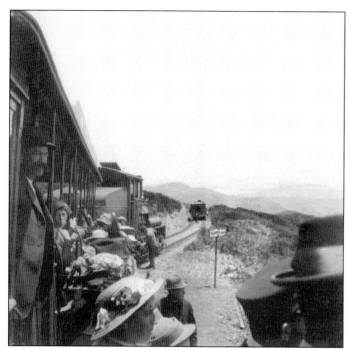

A moment before the train is photographed, passengers collect along its length. Inexpensive photography was still a few years off, so this would be a valuable personal memento of the trip. (Ted Wurm collection.)

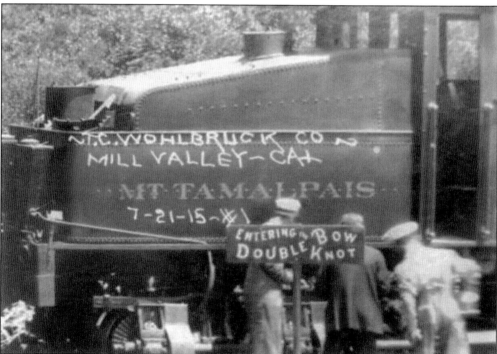

Each photograph was dated and numbered. This shot was taken on July 21, 1915, during the peak of the railroad's popularity. It was the first train of the day. When all the morning's trains were on their way up the mountain, photographer T. C. Wohlbruck jumped into a small gravity car and headed to Mill Valley where he developed, printed, and mailed the photographs, which usually arrived home before the travelers did. (T. C. Wohlbruck and Company photograph.)

Six

ON TO WEST POINT

The long climb to West Point, in and out of canyons, is just over 2 miles from the Double Bow Knot. The grade climbs at five percent, rising 5 feet for every 100 feet traveled. The grade passes through Fern Canyon, a wooded water stop for the steam engines and a canyon that was scarred by fire in 1913. The West Point Inn, the only surviving structure of the railroad, is still there. Built in 1904 by the scenic railway for $2,500, the inn still provides simple, rustic, overnight accommodations on the mountainside. It is surprisingly unchanged after more than a century of use, though today it is operated more like a hostel than an inn. Volunteers have run and managed the inn and its five cabins for more than 60 years.

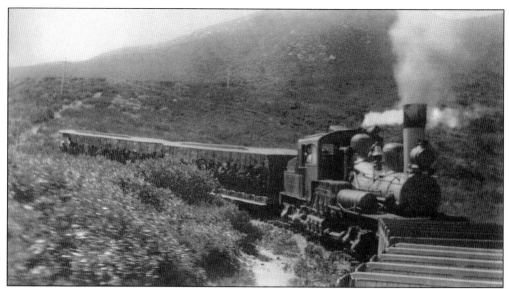

Rounding the turn heading into the longest straightaway on Mount Tamalpais, Bill Provines took this shot on his day off. He loved the job that much. "This is the best action photo I've ever seen of the Mountain Railroad," he said. Engine No. 8 is working hard and efficiently. "A light haze coming from the smoke stack. That's good firing. White steam or black soot meant you weren't doing your job." (Bill Provines photograph.)

Engine No. 8 passes two women hikers on its way up the mountain around 1924. In early days when trails were few, hikers walked the tracks and stepped aside as trains passed. Rapport between hikers and the railroad was generally good. The railway supported hikers and their events, and the Tamalpais Conservation Club newsletters tell of many cooperative events where the railway provided assistance. (Nancy Skinner collection.)

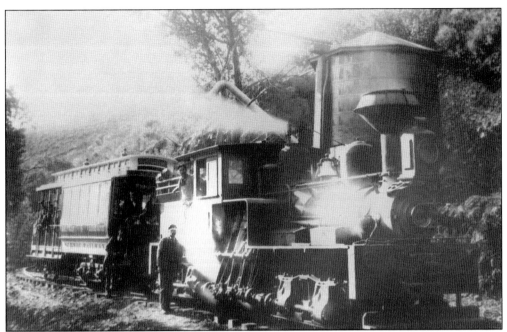

The first engine on Mount Tamalpais, No. 498, takes water at the Fern Canyon water tank around 1898. Shays needed about 2,000 gallons for each trip. The Fern Canyon water tank was probably the first water stop on the mountain, and the only other was at Mesa Station. A hard spot to find today, this place lays a few hundred feet upgrade from where the Fern Canyon trail meets the old right-of-way. (Martin/Jennings collection.)

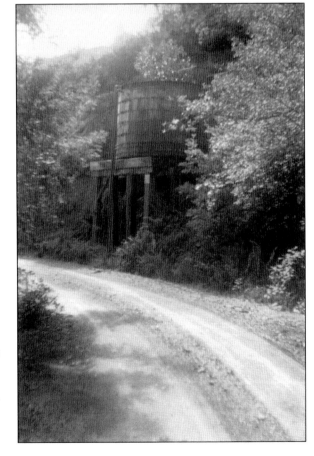

Longtime Tamalpais hiker Harold Atkinson, a man who had hiked the mountain trails in the lifetime of the Crookedest Railroad, snapped this photograph of the Fern Canyon water tank in 1976, about 78 years after No. 498 stopped here for a drink. (Nancy Skinner collection.)

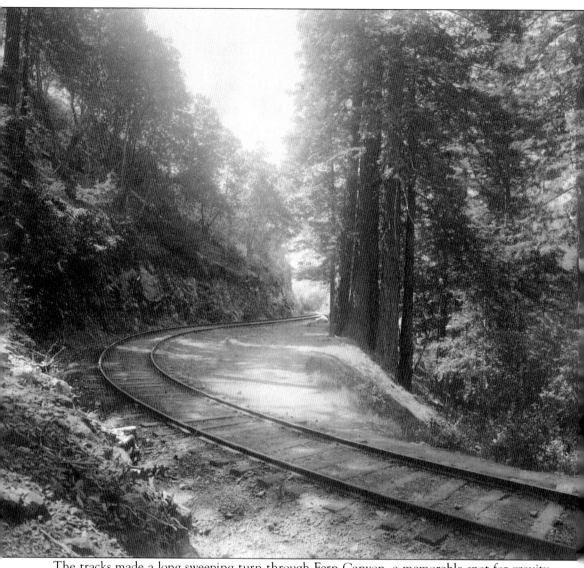

The tracks made a long sweeping turn through Fern Canyon, a memorable spot for gravity cars. The sloping grade eased enough here so if gravity cars did not have enough momentum, they would stop in the turn. Before reaching this spot, the operator released the brakes to gain speed, usually reaching about 25 miles per hour, well over the railroad's 12-miles-per-hour speed limit for gravity cars. His first day operating a gravity car, no one told young Bill Provines about the higher speed limit at this turn. He was operating the last car of a four-car gravity train.

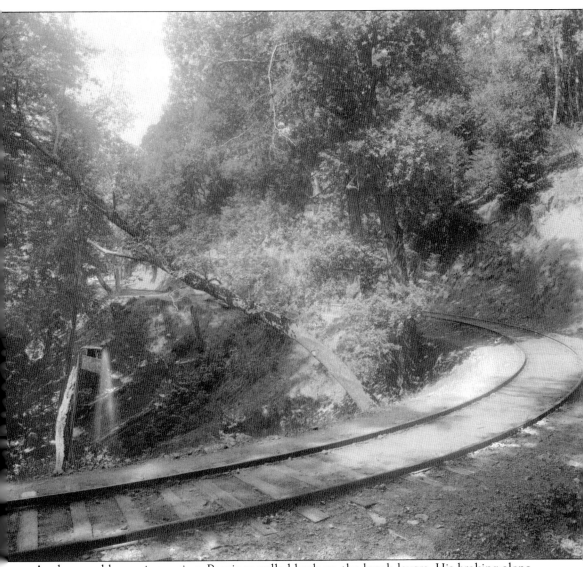

As the speed began increasing, Provines pulled back on the break levers. His braking alone was enough to bring the whole train to a stop. Provines was surprised again when most of the 120 passengers agreeably got out of their gravity cars and helped push the train to where the grade steepened. The dry, sunlit hillside (at right) today is a wet, moss-covered spring. (Lucretia Little History Room, Mill Valley Public Library.)

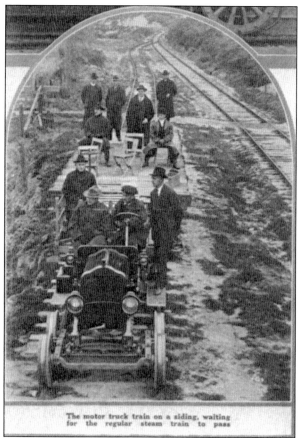

The only known photograph of Bootjack siding comes from the December 1918 issue of *Motor Magazine* and a story of a White truck that proved it could climb Mount Tamalpais as well as a Shay locomotive. Bootjack siding was rarely used in regular operation. It is a likely vestige of construction work in 1896, a place to stage supplies used to build the grade above. (Ted Wurm collection.)

The motor truck train on a siding, waiting for the regular steam train to pass

This *c.* 1910 image looks west from Bootjack siding across the canyon to a railroad outpost called the West Point Inn. A train whistles as it heads down the mountain for Mill Valley. It will take about one minute for the train to reach the viewer. At 12 miles per hour, the speed limit on the scenic railway, trains covered a mile about every 5 minutes. (Ted Wurm collection.)

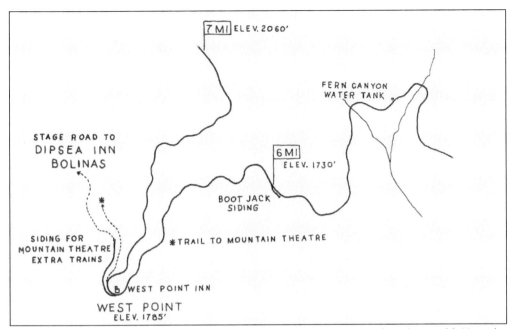

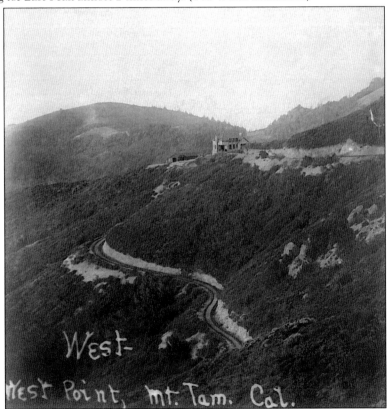

Al Graves drew this map of the western end of the Crookedest Railroad in the World. Here the tracks stopped their westward climb and swung through a 252-degree arc on a narrow ridge and pointed east, climbing for East Peak almost 2 miles away. (Ted Wurm collection.)

The steel rails from Mill Valley climb from the bottom of the frame toward West Point and to the summit at upper right. In early plans, it was called West End or West Loop. The first building was a stable for horses and a stagecoach. The inn was built in 1904 to provide hospitality on a barren, often windswept ridge. (Jim Staley collection.)

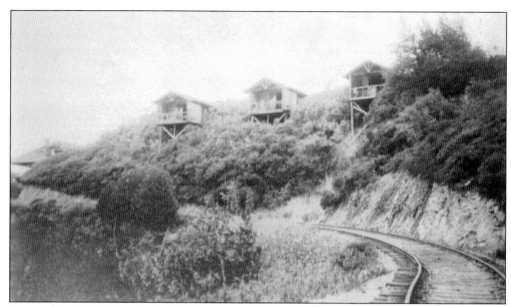

Approaching West Point, the inn's oldest, most outlying cabins were built before 1915. Railway fireman Bill Provines remembers that as the train approached, women who spent the night in the cabins would stand on the porch and wave at the train below. Melanie Kliewe, the innkeeper from 1919 to 1924, said groups of women preferred to book the cabins on the weekends, packing their friends into the dormitory-style bunk beds. (Martin Kliewe photograph; Sue Durkovich collection.)

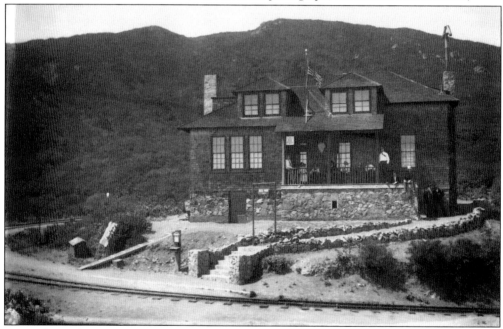

Trains dropped passengers and supplies at the foot of the inn's stone steps beginning in 1904, as shown in this c. 1914 image. The porch was expanded by the railroad in 1916. The inn today is surprisingly unchanged, still using gaslights and offering simple hospitality on a windy ridge. A visitor's experience here can be much like novelist Gertrude Atherton's was at the Tavern in 1905. See page 83 for more on this topic. (Nancy Skinner collection.)

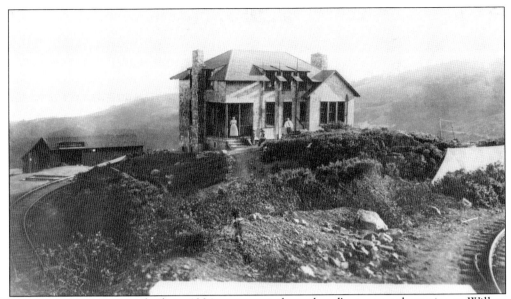

The West Point Inn was built in 1904 to support the railroad's stagecoach service to Willow Camp (today known as Stinson Beach). The stables, seen on the left, were built in 1902. Stage service ended in 1915, and the inn was closed. Regular Tamalpais hikers gave the inn a new job as a "hiking headquarters." It remains that today and has been run by volunteers for more than 60 years. Pictured here may be the inn's first innkeepers. (Ted Wurm collection.)

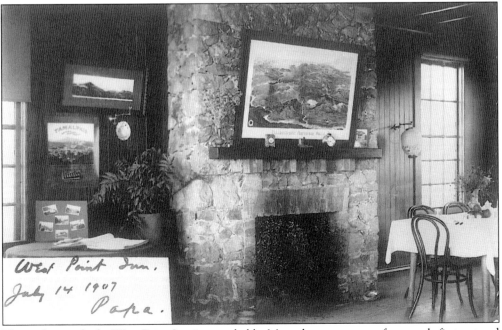

The parlor inside the West Point Inn is remarkable. More than a century after people first entered this room, it still looks much the same. The dark green paint on the walls is now a lighter ivory color, the gaslight fixtures are a little more modern, the pictures have been updated, and the table on the right is still in service. (Jim Staley collection.)

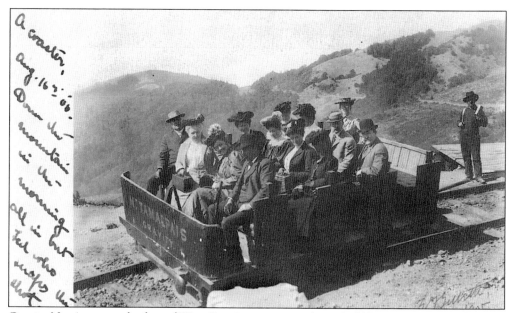

Gravity No. 4 stops at the foot of West Point's stone steps. A total of 32 gravity cars were built by the Crookedest Railroad. The operator, or gravityman, sits in the car's front left seat, where he operated two brake levers. Later models put him in the right seat. Gravity cars evolved until 1910, when they carried as many as 30 people in church pew–style seats. (Jim Staley collection.)

The fanciest cabin at West Point was built in 1918 by Dr. Washington Dodge, a survivor of the RMS *Titanic*. Dodge boarded lifeboat No. 13 because his steward, F. Dent Ray, felt his skills as a physician would be helpful in the drifting lifeboats. Dr. Dodge, his wife Ruth, and their four-year-old son, Washington Jr., the only passengers from San Francisco, survived the most famous maritime disaster of all time. (Frank D. Nicol collection.)

Stagecoach service carried railroad passengers to and from Willow Camp (Stinson Beach) before the inn was built, beginning in 1902. A rookie bandit's hold-up attempt was foiled by veteran stage driver Harry Ashe while the new inn was under construction. The service, slow and expensive on the steep mountain, was never popular despite its Wild West aura and was abandoned in 1915. (Martin/ Jennings collection.)

Willow Camp and Bolinas
Via Sausalito Ferry, Foot of Market Street

DAILY STAGE via WEST POINT
MOST SCENIC STAGE RIDE IN CALIFORNIA

From May 1 to October 1, 1913

	Week Days	Sundays and Holidays
Leave San Francisco via Sausalito Ferry	1:45 P.M.	2:45 P.M.
" Mill Valley via Mountain Railway	2:40 P.M.	3:40 P.M.
" West Point via Stage	4:00 P.M.	4:30 P.M.
Arrive Willow Camp via Stage	5:00 P.M.	5:20 P.M.
" McKennan's Landing via Stage	5:30 P.M.	6:00 P.M.
" Bolinas via Launch	5:45 P.M.	6:15 P.M.
Leave Bolinas via Launch	1:15 P.M.	1:40 P.M.
" McKennan's Landing via Stage	1:30 P.M.	2:00 P.M.
" Willow Camp via Stage	2:00 P.M.	2:30 P.M.
Arrive West Point via Stage	3:45 P.M.	4:15 P.M.
" Mill Valley via Mountain Railway	5:40 P.M.	5:40 P.M.
" San Francisco via Northwestern Pacific	6:35 P.M.	6:35 P.M.

FARE

Round Trip		One Way
$0.40	San Francisco to Mill Valley, Northwestern Pacific R. R.	$0.25
1.50	Mill Valley to West Point, Mt. Tamalpais Railway	.90
1.75	West Point to Willow Camp or McKennan's, Stage	1.00
.50	McKennan's to Bolinas via Launch	.25
$4.15		$2.40

MANUEL NUNES,
West Point Stage,
Telephone "Bolinas 64"

WM. H. McKENNAN,
Bolinas Launches,
Telephone "Bolinas 62"

SPECIAL STAGE OR LAUNCH CONNECTIONS CAN BE ARRANGED
FOR BY TELEPHONING THE ABOVE

The stagecoach route from West Point initially ended at the Dipsea Inn out on the Sea Drift sand spit of the Bolinas Lagoon. The Dipsea Inn was the birthplace of the Dipsea Race, the second-oldest foot race in America. The stage road, built by hand for $5,000 in 1902, is today partly buried beneath the Panoramic Highway from the Pan Toll Ranger Station to Stinson Beach. (Dewey Livingston collection.)

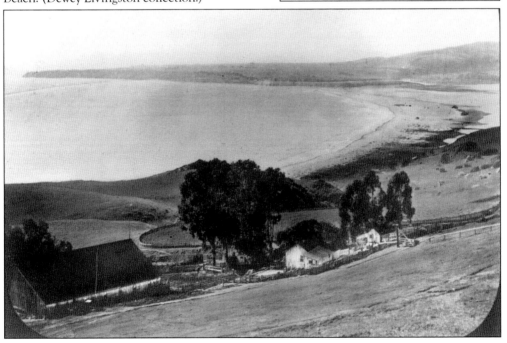

69

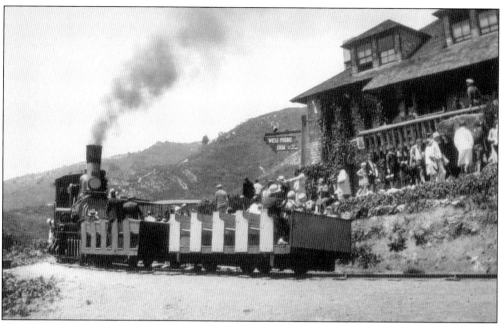

The West Point Inn is the story of an underdog. It was a modest stop on the Crookedest Railroad, rarely mentioned in the railroad's brochures and literature. Today it stands as the most important building they ever constructed, the only survivor of the once-famous scenic railway. (Nancy Skinner collection.)

Ralph Kliewe's (Klee-way) parents ran the West Point Inn from 1919 to 1924. It was like heaven living with his very own steam railroad. The train crews were friends and an extended family, keeping an eye on Ralph on the free rides he received to the Tavern, then returning him on the next train to the West Point Inn. (Nancy Skinner collection.)

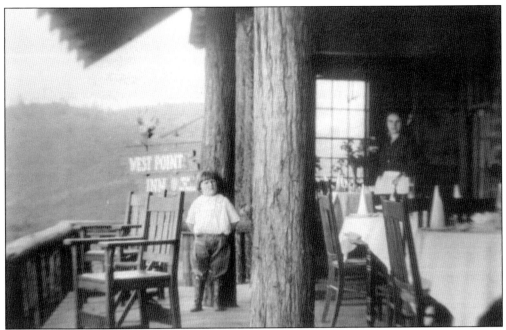

When the Kliewes (Klee-way) came to West Point Inn, hiking newsletters stated, "Their enthusiasm and hospitality has transformed the inn." Indeed, they added a much-needed dining room opening with a festive evening at the inn on April 24, 1920. These porch tables may have been set for playgoers for the annual mountain play, when thousands came by train for the big event. (Nancy Skinner collection.)

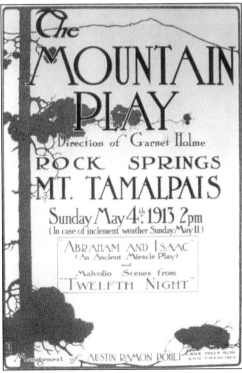

This was the playbill for the first mountain play, a biblical production called *Abraham and Isaac*. Mountain play productions have been staged almost every year since. For the first 17 years, the railway and the mountain play complemented each other. In fact, the week before the show the actors and director stayed at the West Point Inn, hiking to the theater for daylight rehearsals. (Martin/Jennings collection.)

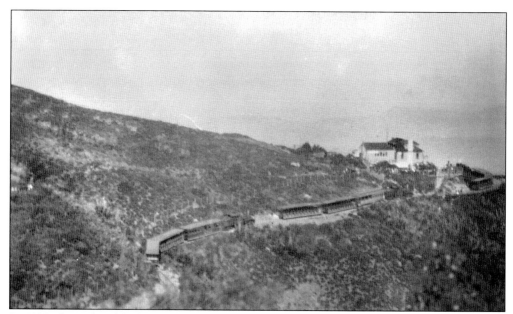

In 1920, the railroad laid track on the Old Stage Road and built platforms to handle throngs of people who came to see *As You Like It* performed at the Mountain Theater. The railroad has also put new shingles on the 16-year-old West Point Inn and the new dining room addition. (Martin/Jennings collection.)

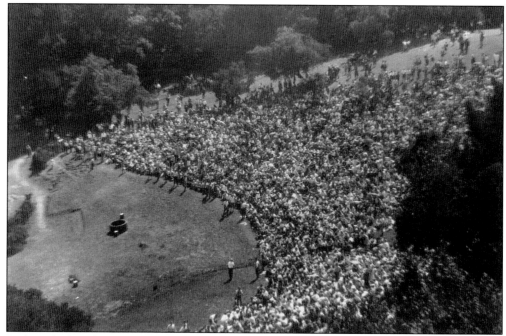

In the early days, the Mountain Theater was an open meadow with a bridgeless bay and San Francisco providing a unique backdrop. Theatergoers could hike to the show or take the train to West Point and hike from there. The inn offered special chicken dinners. Theatre-lovers made reservations as they stepped from the train that morning. The stone seats and rustic buildings were constructed by the Civilian Conservation Corps (CCC) in the 1930s. (Martin/Jennings collection.)

Seven

THE SUMMIT

A half mile above San Francisco Bay trains arrived at the Tavern of Tamalpais, a grand lodge with a restaurant, a dance pavilion, and a magnificent view. All kinds of people came by train: tourists, celebrities, politicians, and writers. Thomas Edison's kinetoscope motion picture crew was here in 1898, shooting what were likely the first motion pictures made in Marin County. The Tavern began small and grew. It soon became a landmark and a place of revelry. Suddenly and sadly, it burned to the ground in 1923. A new mission-style Tavern was built for dining and dancing but had no overnight accommodations because people were less interested. The new stucco Tavern outlasted the railroad. The U.S. Army took it over for wartime use in World War II. In 1950, it was demolished and not rebuilt.

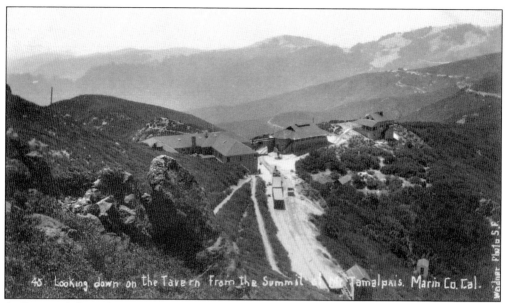

At East Peak from the rocks near the summit is a great view of the Tavern and the yard where trains and gravity cars waited for passengers for the next trip down the mountain. The other buildings are the dance pavilion (center) and the U.S. weather station (right). In the distance, above the weather station, is the West Point Inn, almost 2 miles away. (Jim Staley collection.)

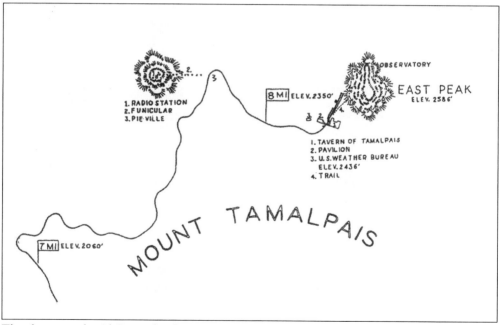

The above map by Al Graves has been amended slightly by the author. It shows the layout of the railroad around Middle Peak, "Pie Ville" (3), which is also known as the San Rafael turn—the place where passengers got their first glimpse of the city of San Rafael. It also shows the tracks to East Peak and the buildings there. (Ted Wurm collection.)

Looking west across the rooftops of the Tavern and dance pavilion are two wooden radio towers at Middle Peak. This twilight view shows the funicular railway that ran between the towers and a spot on the railroad known as "Pie Ville." Pie Ville is a railroad term for a place where rails come together—often at a switch. The funicular rails did not actually connect to the mountain railroad. (Bancroft Library, University of California, Berkeley.)

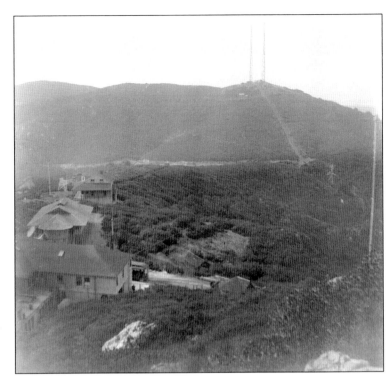

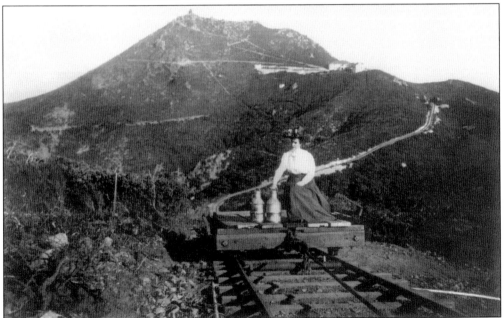

The funicular railway to Tamalpais's Middle Peak was a short-lived part of the mountain road, which is not hard to imagine judging by this woman's expression. In 1905, two 300-foot wooden radio towers were built by the Pacific Wireless Telegraph Company for communications with Hawaii and perhaps Japan. They were blown down on December 10, 1906, and never rebuilt. Today the peak is covered with antennae. Note the heavy rope pulling a car and its contents. (Lucretia Little History Room, Mill Valley Public Library.)

This 1928 photograph gives a rare view of a train just below the Pie Ville/San Rafael Curve. It was taken from Ridgecrest Boulevard, an unpaved toll road that contributed to the demise of the railroad. (Barbara Voisin collection.)

The mountain railroad's single-car train whistles on its way toward Mill Valley. In this canyon, the whistle's sound would have ricocheted back and forth for several seconds after the engineer was finished. In the days before radios, the melancholy sound of steam whistles communicated many things from the engineer to the people on his train or nearby. Sometimes it was inspiration to those who wrote music. (Barbara Voisin collection.)

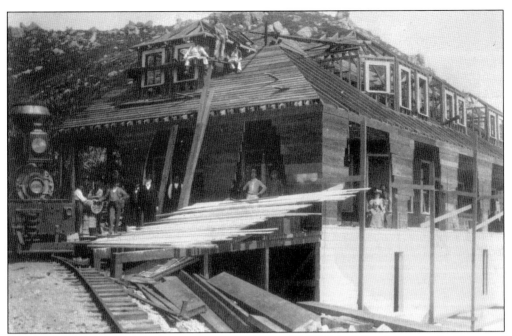

Almost as soon as the last spike was driven on August 18, 1896, building began on the Tavern of Tamalpais. During construction, Susan B. Anthony spoke before the California Women's Suffrage League and the Pacific Coast Women's Press Association, who were guests of the scenic railway on September 16, 1896, at Tamalpais's East Peak. (Martin/Jennings collection.)

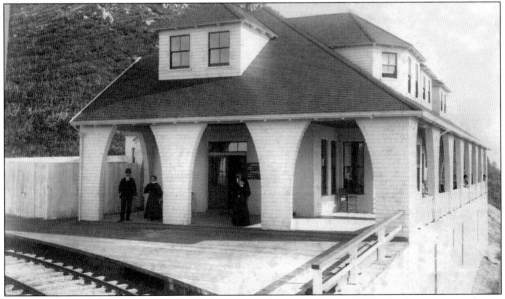

Construction moved along quickly, and by the end of September 1896, the Tavern was almost finished. The lodge and railway complemented each other nicely. The Tavern was an attraction and a convenience for railway's passengers, while the rail line literally brought the business to the Tavern's front door. The lodge had incredible views in almost every direction, eight new rooms lit by gas light, and a restaurant less than two hours by train from San Francisco. (Martin/Jennings collection.)

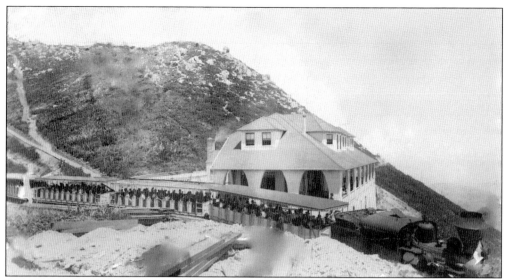

The new scenic railway was a huge success. The little Tavern and modest restaurant were overwhelmed, which is not hard to imagine looking at this train. The railroad moved quickly and began construction of a second building, with its beginnings on this freshly turned mound of earth. The new building became the new larger dining room and was connected with the Tavern by an archway that bridged the tracks. (Lucretia Little History Room, Mill Valley Public Library.)

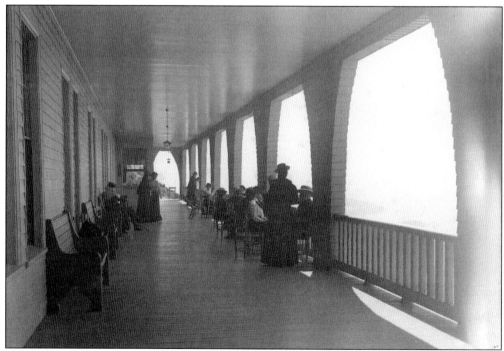

When the Tavern first opened in 1896, the long 180-foot porch offered plenty of fresh air and a superb view of rural Marin County, the big city, and the San Francisco Bay Area. The Tavern and its accommodations were simple and elegant, perhaps echoing some of the amenities at Sidney Cushing's Blithedale Hotel. (Bancroft Library, University of California, Berkeley.)

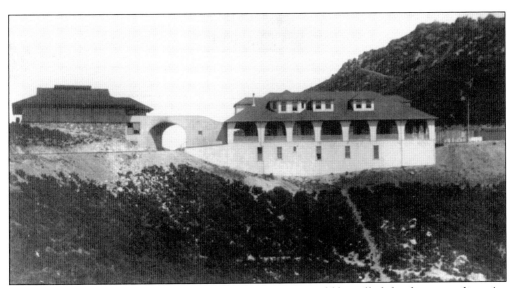

The building on the left is the new dining room. Later it would be called the dance pavilion. An archway over the tracks connected it to the Tavern. This was how the East Peak looked when Thomas Edison's kinetoscope film crew shot here in March of 1898. Their movie footage is in the Library of Congress and can be found on the Internet with the search: "mount tamalpais railroad congress." (Ted Wurm collection.)

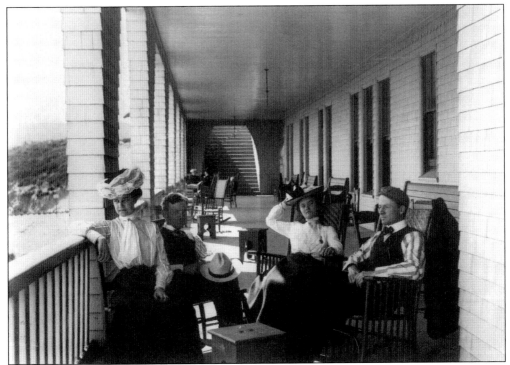

On a hot summer day at East Peak temperatures can reach over 100 degrees, inspiring most any gentleman to doff his coat. The stairs in the background lead to the top of the archway. On the left is a small piece of the railroad grade seen just before it enters the archway. (Ted Wurm collection.)

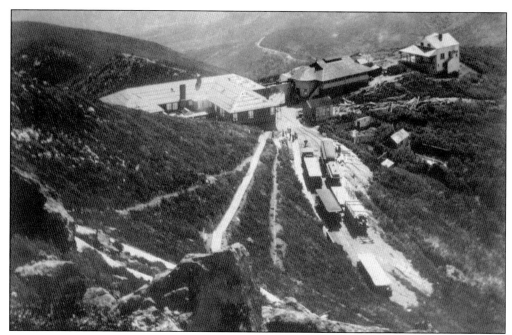

The Tavern was enlarged in 1900, and the porch and second story were expanded, adding new rooms and guest facilities. There is a scaffold around the building and signs of roofers. A flatcar of freshly milled lumber is in the yard. Scraps of construction and pieces of the old Tavern lay on the path alongside the former dining room, now the dance pavilion. (Ted Wurm collection.)

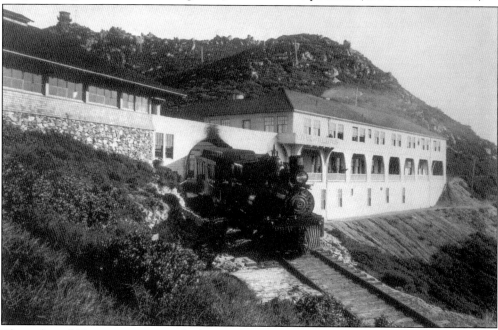

The enlarged Tavern was painted white as before. An old brochure told of 30 new rooms "in suites with private parlors and baths, extensive dining halls, huge fireplaces, cheerful apartments thoroughly heated and lighted with gas [and furnished with] hot and cold water." (Martin/Jennings collection.)

Some of the workmen who expanded the Tavern are gathered around their slapdash wooden work cart with its crude but adequate brake. It was used to move lumber and supplies from the stacks in the yard to the work area. This was arguably the most unusual contraption to ever "run" on the Mount Tamalpais rails. (Ted Wurm collection.)

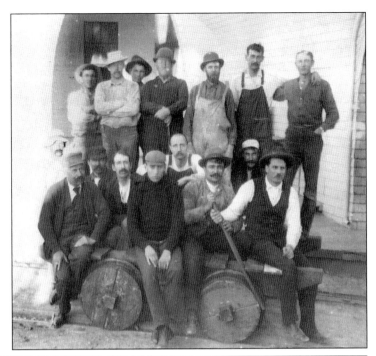

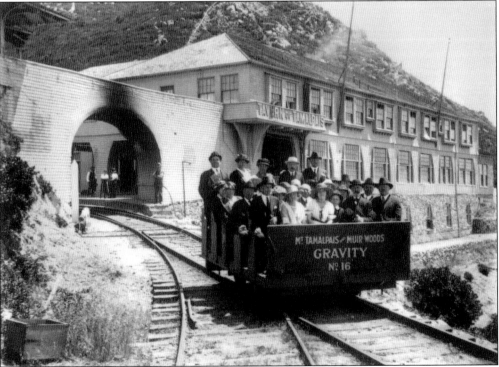

The Tavern, seen here around 1922, changed little after the 1900 expansion. The porch arches were glassed in, and flagpoles were added. It is unclear when the safety track (running beneath the camera) was added. The switch under gravity car No. 16 was set to divert any runaway into the hillside rather than let it roll down the mountain. (Ted Wurm collection.)

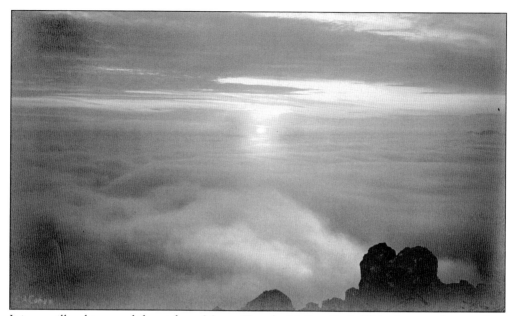

It is now illegal to spend the night at Mount Tamalpais's East Peak. This photograph was taken when visitors could. The rocks in the foreground are at the mountain's summit. The clouds reach to the horizon. The winter sun and the peaks of Mount Diablo are visible. (E. A. Cohen photograph; author's collection.)

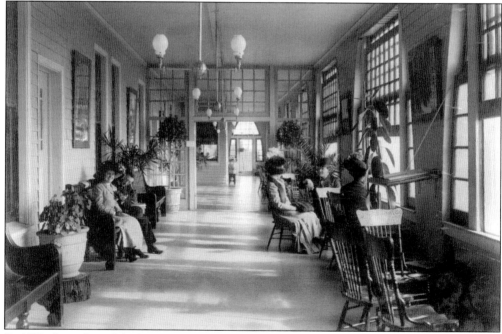

By 1910, the arches of the Tavern's veranda were filled with glass windows. There is an open airy feeling looking down the porch and through the restaurant. At the far end of the building is the Racetrack Trail, "A level continuous 20 minute walk around the mountain," several signs stated. There were sighting scopes along the way to point out the landmarks. See page 90 for more on this topic. (Ted Wurm collection.)

Popular novelist Gertrude Atherton wrote her favorite book, *The Tower of Ivory*, at the Tavern in 1905. Atherton wrote, "But the winter turned abruptly into summer and people came up on the little mountain train to witness the sunrise next morning. I was awakened by 'Ohs' and 'Ahs' as they hung out of their windows at four a.m., watching a blood-red sun rise above an imponderable sea of white fog." (Bancroft Library, University of California, Berkeley.)

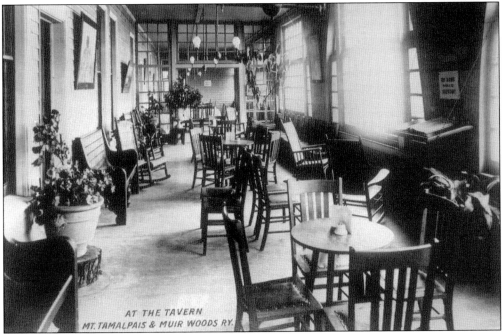

AT THE TAVERN
MT. TAMALPAIS & MUIR WOODS RY.

The archways of the porch were enclosed to protect guests from the sometimes harsh weather at the mountaintop. At times, winds could sweep across the peak with such ferocity that a 74,000-pound Shay locomotive would sway back and forth on the tracks of the yard, her crew in the cab tending the locomotive. (Martin/Jennings collection.)

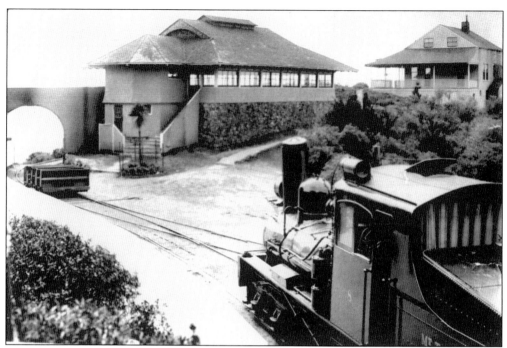

The second structure built at East Peak had a sweeping view through dozens of glass windows. Built as a dining room to handle the multitudes of people who came when the railroad first opened, this became the dance pavilion where couples danced as musicians played, and the Bay Area was the backdrop. (Nancy Skinner collection.)

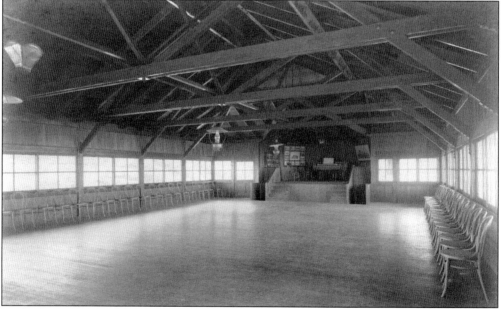

Under the gentle glow of kerosene lanterns, couples danced and musicians played on the stage at the far end of the room. Outside, through the glass windows, the clouds are lit by the moon. Glimpses of San Francisco twinkle through from time to time, but most of the Bay Area is black, its population a fraction of today's. (Lucretia Little History Room, Mill Valley Public Library.)

POST CARD

Miss Miriam Deutsch,
1908 a. Baker St,
San Francisco,
Cal.

THIS SIDE IS EXCLUSIVELY FOR THE ADDRESS.

Mailed from the Tavern two days before the 1906 San Francisco earthquake and fire, "Aunt Fannie" was having a great time. She wrote, "Dear Mim, This is simply beautiful. Wish you were up here with me. Lovingly, Aunt Fannie." The Tavern had its own post office, which opened for business on February 1, 1906. The Tavern's post office closed on November 6, 1929, six days after the last tourist train left Mount Tamalpais. (Author's collection.)

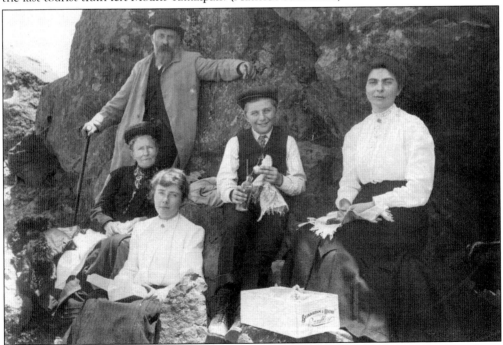

Not everyone dined at the Tavern. This family enjoyed a nice box lunch atop Mount Tamalpais. They bought a lunch packed in a shoebox from San Francisco shoemakers Buckingham and Hecht on July 22, 1905. These were the days before "paper or plastic?" (John Zuffinetti collection.)

This postcard and the one on the top of the next page show views inside the Tavern. There are gas lamps and large framed photographs of the railroad's landmarks. These photographs were also used on the souvenir postcards. There are similarities to the West Point Inn with the design of the doors and transom windows above them. (Martin/Jennings collection.)

The Tavern's archway was a focus for activity, just like the proscenium of a theater. There was drama in the mountain train's arrival as it chugged up the steep grade, slipped beneath the arch, eased to a stop, and released passengers on the other side. The afternoon train, Shay No. 4, pushes three passenger coaches to the platform in the yard beyond around 1915. (John Zuffinetti collection.)

This postcard view overlaps the "office" on the previous page. Note the same table, chairs, and upright piano in each. The doorway on the left side of this card leads to the dining room at the east end of the Tavern. Above the fireplace is a photograph of the first Muir Inn, built by the railroad in 1908. (Lucretia Little History Room, Mill Valley Public Library.)

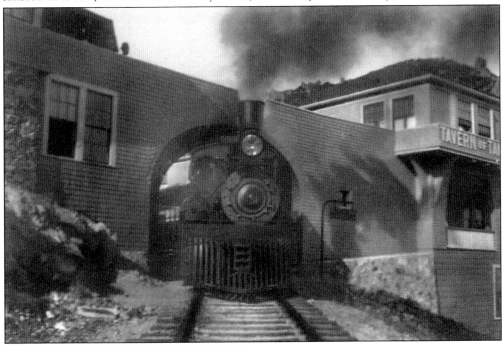

This view also overlaps the photograph at left, capturing the instant just before Engine No. 4 slips under the shingled archway and the smoke thickens in the smokestack. The smoke comes because as the engineer closes his throttle, bringing his train to a stop, the fireman must also reduce the fire under the boiler. If they are out of sync, the haze from the smokestack turns to smoke. (John Zuffinetti collection.)

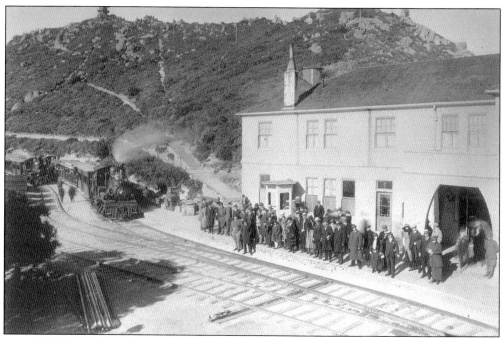

Here is a rare look at train movement in the busy Tavern yard. Three trains at the north end of the yard are steamed up and close to departure. Passengers gather along the platform, ready to board. Soon the fireman begins ringing the locomotive's bell, there is the hiss of air as the brakes are released, and No. 7 moves forward toward the archway. (Martin/Jennings collection.)

This January 1916 photograph shows where locomotives came to a stop for boarding in the shadow of the arch. Above the 8 Spot on the second floor of the Tavern is the ladies' lounge, a "corner office" with a view to die for. It was the counterpart to the men's smoking room found in many establishments of the day. (George B. Dabney photograph.)

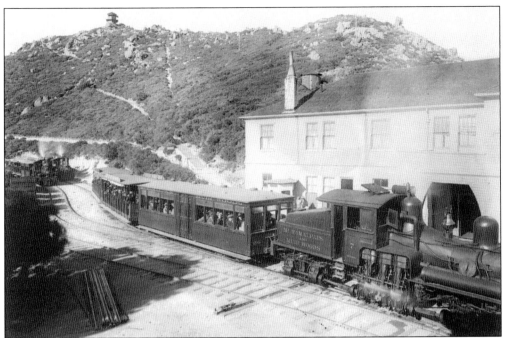

Moments after the photograph on the previous page was taken, Engine No. 7 sets its brakes, stopping just short of the archway and the passengers on the platform climb aboard. (Ted Wurm collection.)

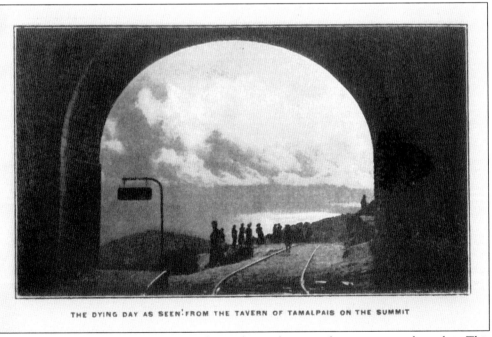

THE DYING DAY AS SEEN FROM THE TAVERN OF TAMALPAIS ON THE SUMMIT

For all the photographs of the Tavern and its archway, there are almost no views through it. This is what an engineer would have seen just before departure. This image, from a souvenir booklet, gives a sense of the view, the light late in the day on the Pacific Ocean, and the sheen from some well-used rails, their tops polished by frequent use. (Author's collection.)

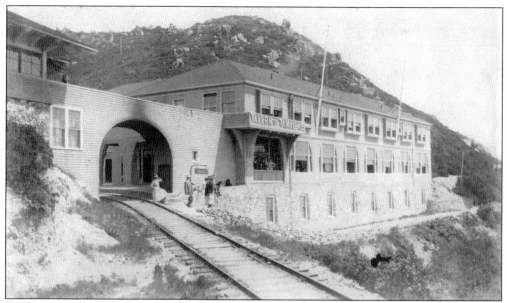

To the right of the archway, a metal sign marks the beginning of the Racetrack Trail, stating, "Level continuous walk of 20 minutes around the mountain." Not long after completing the Tavern, the railroad carved the level trail around the peak so finely dressed folk could take an easy walk to see all the sights. (Ted Wurm collection.)

Along the Racetrack Trail, lensless sighting tubes helped find sights such as San Francisco's Cliff House, the Golden Gate before the bridge, a military prison on Alcatraz Island, Goat Island (today called Yerba Buena Island), the University of California in Berkeley, and San Quentin State Prison. The tubes were actually recycled tubes from the locomotive boilers that had been cut, labeled, and planted along the trail. (Author's collection.)

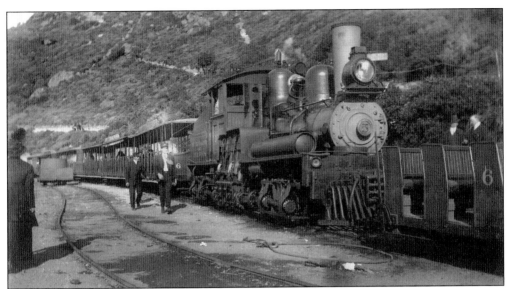

The Racetrack Trail (visible to the middle left) returned to the Tavern overlooking the activity in the rail yard and ended at the passenger boarding platform. Today it is called the Verna Dunshee Trail. (Ted Wurm collection.)

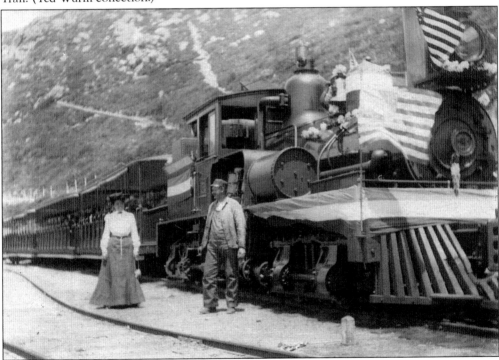

On July 4, 1903, at the summit yard, Engine No. 3 is decked out for the occasion. Flags, flowers, and bunting were an important part of the holiday festivity. National holidays were reverently observed early in the 20th century. Occasionally they were three-day weekends. Memorial Day (also Decoration Day) was always May 30 (until 1968) and included formal flag-raising ceremonies at sunrise to honor fallen veterans. Today many consider Memorial Day the first weekend of summer. (Author's collection.)

This is the only known image of Frank Newsome, who photographed untold thousands of people. Whether up at the Tavern, on the summit, or down in Muir Woods, Ransome always wore a hat. This is the only known photograph of him, standing next to a Gray Line bus, with a simple box camera in his right hand. Some of his work is here, each with "Frank Ransome, Fotographer [sic]" stamped on the back. (Ted Wurm collection.)

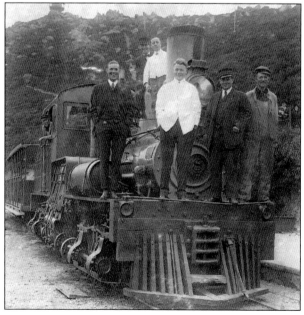

People smile vibrantly in Frank Ransome's photographs. This one must have a great story with the train crew, some waiters, and a Tavern guest—likely a friend—all laughing at dusk in the summit yard. Unfortunately, in all the years since it was shot, the story has been lost. (Ted Wurm collection.)

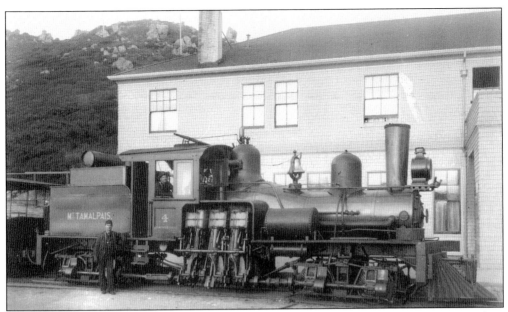

The soft light just after the sun drops below the horizon shows the attention the crew gave their locomotives. The fading light shows the smooth, clean, unblemished red-maroon paint and the polished brass of engine No. 4. Her crew is engineer Frank Clark and fireman Roy Graves, both waiting for passengers to come from a banquet at the Tavern or a dance at the pavilion. (Frank Ransome photograph; Martin/Jennings collection.)

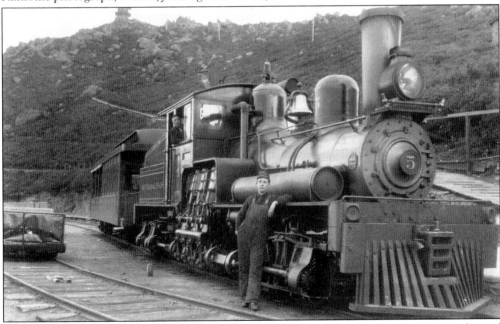

A young fireman named Roy Graves leans against the running board of engine No. 5 as he and senior engineer Jake Johnson wait for the return of their passengers. It is 1907, and dusk comes to the summit yard located a half mile above San Francisco Bay. Roy Graves would become a noted Bay Area rail historian. Many of these photographs were gathered by Graves. (Frank Ransome photograph; Ted Wurm collection.)

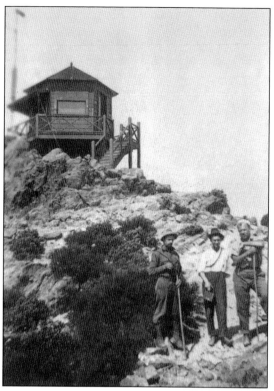

A small observatory was built by William Randolph Hearst's San Francisco *Examiner* on the East Peak in 1901. Its job was to monitor ship traffic up and down the coast and report to the *Examiner* for its five daily editions. The Marine Exchange became obsolete as Marconi's wireless telegraph became more common. In 1935, the observatory was replaced by the present lookout, built by the Civilian Conservation Corps. (Martin/Jennings collection.)

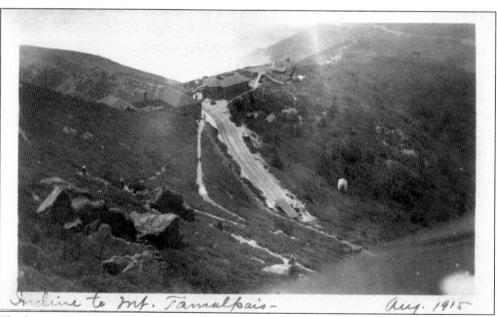

Incline to mt. Tamalpais – *Aug. 1915*

The famous fog of San Francisco could rise and fall along the mountainside and at times smother the Tavern, sometimes obscuring everything. But that was rare. By the Fourth of July weekend, the fog becomes almost locked in a consistent pattern that keeps it off the summit for the summer. For a while, the railroad offered a refund if fog blocked the summer view. This view is from the observatory. (John Zuffinetti collection.)

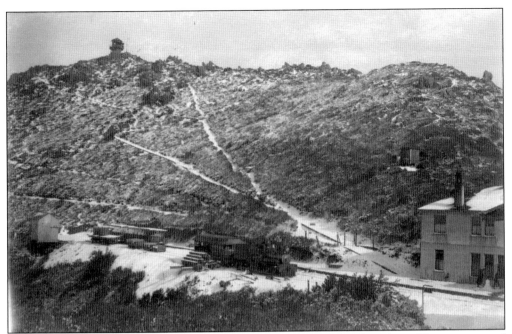

Snow is rare thing on Mount Tamalpais. When it occurs, it seldom lasts long. The summit yard is dusted with a few inches. A small snowman stands near the Tavern. (Ted Wurm collection.)

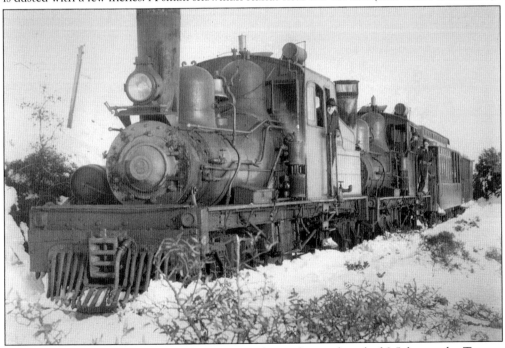

On January 30, 1922, a rare coastal snowstorm dumped an unheard of 3.5 feet at the Tavern, stranding tourists on a quiet Monday. A powerful Shay double-header, only used on the busiest of days on the biggest of trains, was dispatched from Mill Valley with a crude snowplow attached. On the way up the mountainside the powerful train got bogged down in the slush, and the rescue had to wait until the next day. (Ted Wurm collection.)

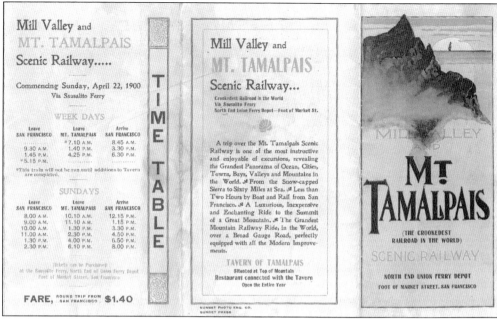

The cover of a brochure from 1900 shows the railroad's schedule. Before the Internet this was how attractions promoted themselves. The other side illustrates the trip in words and photographs. Vignettes show Mill Valley and the Tavern (though it was being enlarged as this was published). This is also one of the earliest examples of the railroad's use of the slogan the "Crookedest Railroad in the world." (Author's collection.)

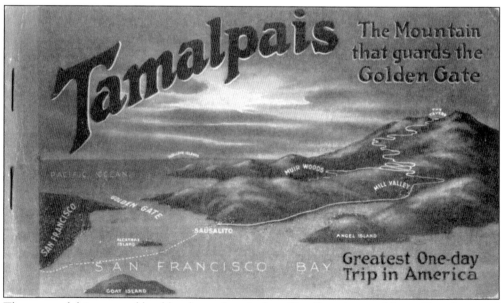

The cover of this postcard booklet shows the trip from San Francisco up Mount Tamalpais and landmarks seen along the Crookedest Railroad in the World. Ten tear-out cards could be used and mailed or saved as mementos of the trip. (Author's collection.)

MT. TAMALPAIS

DO

NOT FAIL TO

TAKE

THIS

TRIP

THE

GRANDEST

MOUNTAIN

RAILWAY

RIDE

ON EARTH

MILL VALLEY AND
MT. TAMALPAIS

SCENIC RAILWAY

"THE CROOKEDEST RAILROAD IN THE WORLD"

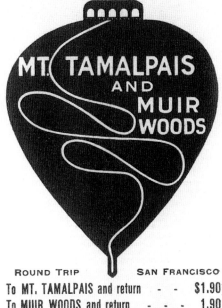

ROUND TRIP	SAN FRANCISCO
To MT. TAMALPAIS and return - -	$1.90
To MUIR WOODS and return - - -	1.90
To MT. TAMALPAIS and MUIR WOODS -	2.90

Trains Run Every Day in the Year

VIA SAUSALITO FERRY
(NORTHWESTERN PACIFIC)

Union Ferry Depot - - - Foot of Market Street

SAN FRANCISCO, CALIFORNIA

TICKET OFFICES

SAUSALITO FERRY
(Foot of Market Street)
TELEPHONE KEARNY 4980

874 MARKET ST.
(Flood Building)
TELEPHONE DOUGLAS 4407

GENERAL OFFICE, MILL VALLEY, CAL.

SEE DAILY PAPERS FOR TIME TABLE

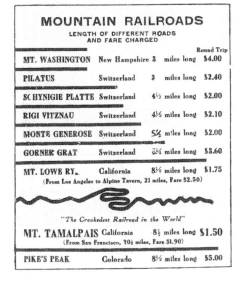

MOUNTAIN RAILROADS
LENGTH OF DIFFERENT ROADS AND FARE CHARGED

			Round Trip
MT. WASHINGTON	New Hampshire	3 miles long	$4.00
PILATUS	Switzerland	3 miles long	$2.40
SCHYNIGIE PLATTE	Switzerland	4⅓ miles long	$2.00
RIGI VITZNAU	Switzerland	4½ miles long	$2.10
MONTE GENEROSE	Switzerland	5½ miles long	$2.00
GORNER GRAT	Switzerland	5¾ miles long	$3.60
MT. LOWE RY.	California	8½ miles long	$1.75

(From Los Angeles to Alpine Tavern, 21 miles, Fare $2.50)

"The Crookedest Railroad in the World"

MT. TAMALPAIS	California	8½ miles long	$1.50

(From San Francisco, 70½ miles, Fare $1.90)

PIKE'S PEAK	Colorado	8½ miles long	$5.00

HOW TO SEE CALIFORNIA IN A DAY

Take the Sausalito Ferry from Union Ferry Depot, foot of Market Street, San Francisco, and go to the summit of MT. TAMALPAIS, via the Mill Valley and Mt. Tamalpais Scenic Railway. A sail on San Francisco Bay, a ride on "The Crookedest Railroad in the World," a continuous ever-changing Panorama of Mountains, Valleys, Ocean, Bays, Cities and Towns, as you gradually ascend to a height of half a mile above the surrounding country. You see more from Mt. Tamalpais than from any other mountain peak in the world; on a clear day the snow-capped Sierra Nevada mountains 155 miles distant can be plainly seen and Mt. Shasta rising nearly three miles high and 300 miles away, can be discerned. The Mt. Tamalpais trip gives one the best idea of locations in California, and you can say with truth after having made this trip that you have seen nearly the whole of California.

This densely packed *c.* 1912 brochure was printed as the railroad was about to change its name from the Mill Valley and Mount Tamalpais Scenic Railway to the Mount Tamalpais and Muir Woods Scenic Railway. Note that the cover shows both names. There is a comparison to other scenic railways and the values in the trip up Mount Tamalpais. There is also a list of all the sights to be seen along the way. (Author's collection.)

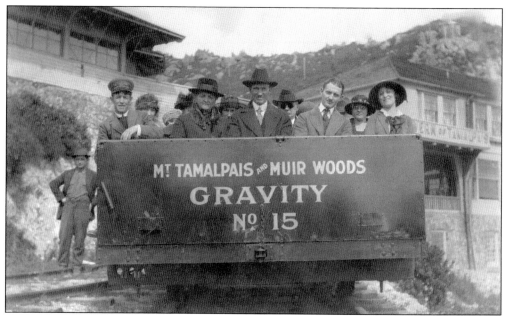

Pictured is the smiling weathered face of John "Pat" Paterson, ready to depart the Tavern in gravity car No. 15 in 1920. Gravity cars were actually scheduled trains. This was important on a single track railroad with two-way traffic because gravity cars had no reverse gear. (Lucretia Little History Room, Mill Valley Public Library.)

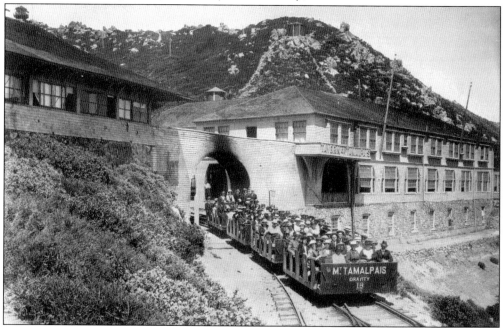

Gravityman John "Pat" Paterson pilots the lead car of a four-car gravity train ready to depart the Tavern in 1922. Each car of a gravity train needed a gravityman to work the brakes. Because of the short, stubby couplers on the cars, a 4-foot "drawbar" was required between the cars. It created space for them to turn. Drawbars were stored beneath each back seat. (Lucretia Little History Room, Mill Valley Public Library.)

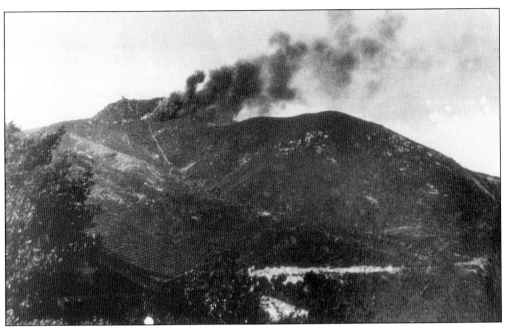

On June 30, 1923, cooks lost control of a kitchen fire that spread quickly through the dry timbers of the Tavern. Soon the whole building was ablaze. (Martin/Jennings collection.)

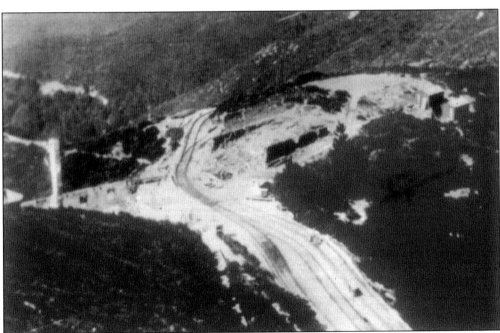

Ashes lay where the Tavern and dance pavilion once stood. The ruins became an attraction. Trains continued to come to East Peak, but the railroad's emphasis shifted to Muir Woods. Ralph Kliewe and his father, Martin, came up from the West Point Inn to see the ruins. Ralph later recalled the ground was hot for two days and "in the bar, all the glass was melted, the bottles and everything." (Martin/Jennings collection.)

The fire started as cooks were cooking chicken in the kitchen. The kitchen was next to the tanks in the middle of the rubble. The innkeepers of the Tavern had a view of the city from their living quarters in the open basement space at right. (Lucretia Little History Room, Mill Valley Public Library.)

From time to time, automobile companies drove their autos up the railroad grade to demonstrate their product was as robust and reliable as a steam engine. A 1923 Chevy PR event shows engine No. 9, the only surviving engine of the scenic railway amid the ruins. Trains still brought tourists to East Peak after the fire. Souvenirs were still sold, but meals and overnight accommodations could only be offered in Muir Woods. (Author's collection.)

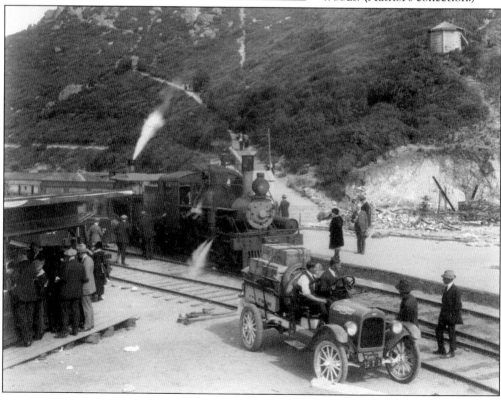

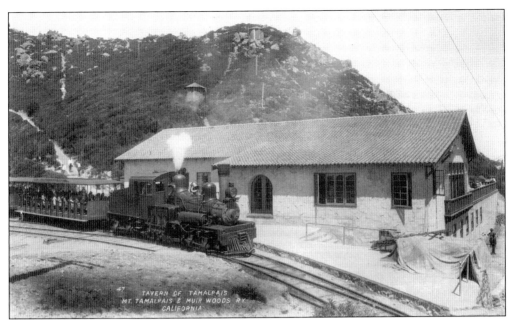

A new Tavern, smaller and with no overnight accommodations, was built on the ruins and opened for business on Thanksgiving Day in 1924. A large open porch extended about as far as the porch of the old Tavern, allowing people to enjoy the sun and the view. Trains and gravity cars departed from the same spot as before. The cement platform and railing next to the engine are still there today. (Author's collection.)

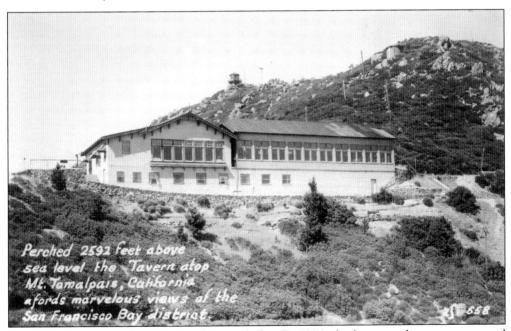

Perhaps the open porch was not such a good idea. By 1926, the large porch was now covered and enclosed and became a spacious dance floor, a place for large gatherings and dances. The stone foundations of the building are still there. Traces of the pink stucco finish survive on the remains. (Author's collection.)

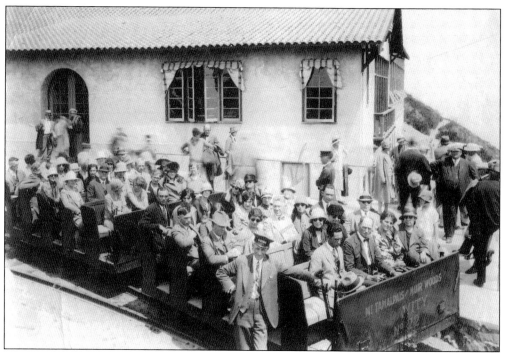

Here is tour guide Bill Osgood and his gravity train at the new Tavern of Tamalpais on August 4, 1926. Osgood stayed in Mill Valley after the scenic railway closed down, opening a bar at the corner of Throckmorton Avenue and Bernard Street. It was called Osgood's Tavern, a nod to his years on Mount Tamalpais. (Frank Ransome photograph; John Zuffinetti collection.)

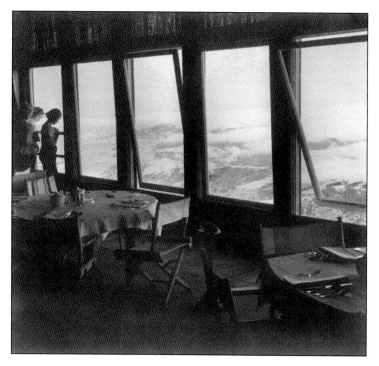

Tavern visitors watch the fog pour across Throckmorton Ridge and into Mill Valley. In October of 1931, almost a year after the railroad was gone, new tavern keeper A. C. Norton told the *Marin Herald*, "I have traveled the world over, but with the possible exception of Genoa, Italy, I know of nothing that rivals, even equals this in panoramic beauty." Norton was the innkeeper of the West Point Inn in 1925. (Lucretia Little History Room, Mill Valley Public Library.)

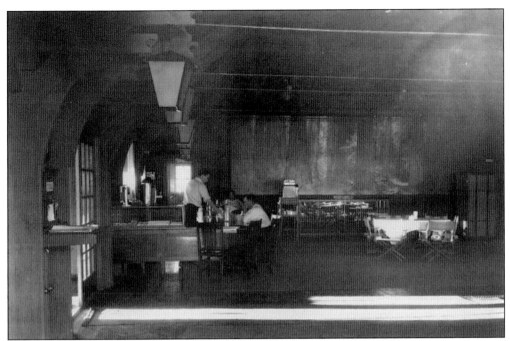

The large mural (actually a photograph) shows the giant trees of Muir Woods. To the left is a restaurant counter with a large coffee urn. Postcards from railroad days show this room full of square tables, with white tablecloths covering them and four folding director's chairs around each table. (Anne T. Kent California Room Collection, Marin County Free Library.)

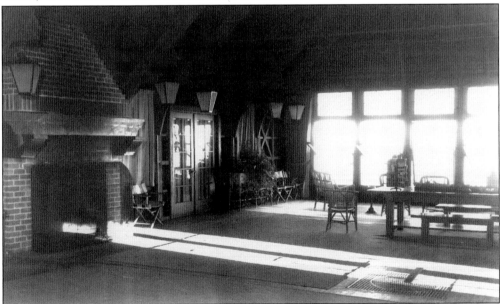

These photographs, taken after the rails were gone, show less activity than when the railroad was there. But these represent the qualities of the interior better than any during the railroad era. Bands of afternoon sunlight come from the doors that led to the track. French doors lead to a large room, which was once an open porch that accommodated close to 600 people. (Anne T. Kent California Room Collection, Marin County Free Library.)

Ridgecrest Boulevard brought automobiles to the Tavern beginning in 1925. As more autos came, fewer and fewer people took the train. Ridership plummeted when the Panoramic Highway opened in 1929. Sunday, normally the busiest day of the week with three trains, now needed only one. (Martin/Jennings collection.)

This brochure illustrates part of what put the scenic railway out of business. The Gray Line buses were new, quieter, and more versatile than steam engines. They followed roadways, not just rails. (The ride was probably bumpier.) The Tamalpais trip by ferryboat and railroad up to the summit, to Muir Woods, and back cost $2.90. The bus trip cost $5 and included a view of San Quentin State Prison. (Author's collection.)

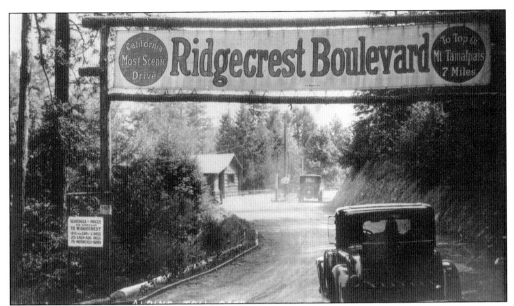

Ridgecrest Boulevard took three years to complete. Winding 6.7 miles from the Bolinas-Fairfax Road to Mount Tamalpais's East Peak, the unpaved road was completed on November 10, 1925. Ridgecrest continues to be a popular place for autos. Every year carmakers send prototypes from Detroit, Europe, and Japan to be photographed against Tamalpais's unmatched scenery. (Martin/Jennings collection.)

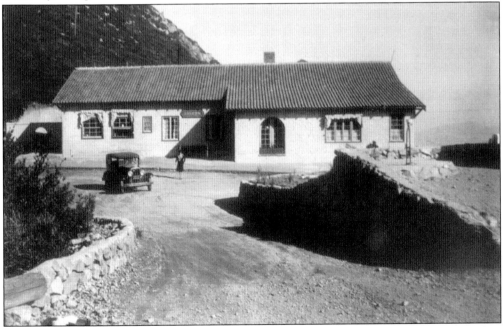

With the scenic railway gone, people continued to come via the unpaved road to see the sights. In 1950, the road was paved when the California State Park took title of the land from the Marin Municipal Water District (MMWD). The new head ranger felt the vandalized Tavern should be torn down and replaced with something more modern, but the funds were never found. (Martin/Jennings collection.)

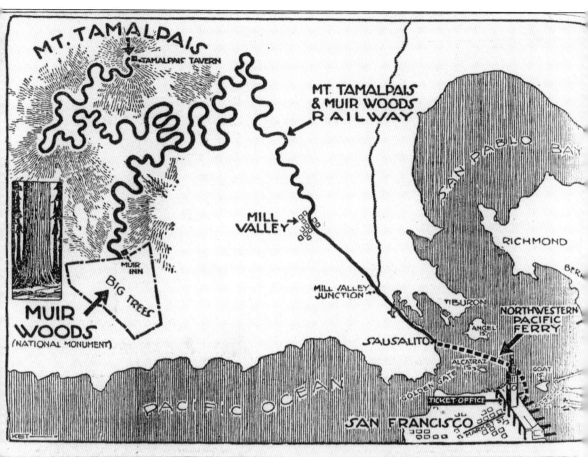

"America's Greatest One-Day Trip. The Crookedest Railroad in the Wor

Twelve miles from San Francisco

No Cogs No Cables Steepest Grade, 7 Per Ce

HOTEL ACCOMMODATIONS AT MUIR WOODS INN

This caricature exaggerates the trip on the Crookedest Railroad—but not much. From a 1925 travel publication, this piece shows how the railroad did not expect guests to spend the night at the new Tavern. (Ted Wurm collection.)

Eight

RAILS TO MUIR WOODS

Muir Woods was a great fit for the scenic railway. The semiarid wilderness on the slopes of Mount Tamalpais was a great compliment to the dark earthy forest in the Redwood Canyon. Protected by steep canyon walls and a shallow creek, the old growth redwoods of Muir Woods were able to avoid loggers who found easier forests to harvest. Philanthropic Marin residents William and Elizabeth Kent bought Redwood Canyon in 1905 solely to preserve the ancient trees. They gave the canyon to the nation, the first parkland ever donated by individuals. On January 9, 1908, Muir Woods became the 10th national monument in America. John Muir wrote William Kent, "This is the best tree-lovers monument that could possibly be found in all the forests of the world. You have done me a great honor, and I am proud of it." The railroad brought the first tourists to see the giant trees in 1907, months before the woods became a national monument. Preserving Muir Woods, though, was not just good business; there was a personal interest as well. Founding president Sidney B. Cushing loved Mount Tamalpais since childhood. Bill Thomas, the railroad's master mechanic, was a well-known railroading genius. Thomas also loved to tell visitors about the marvels of Mount Tamalpais and "the Woods." As the scenic railway was being dismantled in 1930, Bill Thomas, for a short time, was the head ranger at Muir Woods. On May 30, 1923, Sir Arthur Conan Doyle, creator of the Sherlock Holmes mysteries, rode the scenic railway with his family, visiting the Tavern and taking a gravity car to Muir Woods. Conan Doyle was impressed, saying, "In all our wanderings we have never had a more glorious experience." Conan Doyle's rare book, *Our Second American Adventure*, gives an account of his day on Mount Tamalpais and in the "primeval canyon" of Muir Woods. He noted that the scenic railway was a good steward of its lands: "The whole mountain has been most reverently and excellently developed by a private company. It could not have been better done, for it has been made accessible and yet tenderly guarded from all vulgarity. One is not allowed to pick a flower in the Redwood Grove. The latter place has been taken over by the government, and one feels that it should all [Mount Tamalpais and Muir Woods] be national property." Today the lands Conan Doyle saw and enjoyed are a preserved mix of water department and state and national parklands.

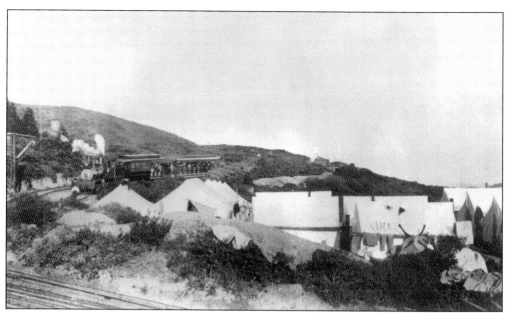

Construction of the branch to Muir Woods began in 1906. A work camp was thrown up at the Double Bow Knot where the Muir Woods Branch left the main line. Rows of canvas tents were surrounded by ties, rails, and the tools of construction. Mesa Station is at left. The line would be completed in 1907. (Ted Wurm collection.)

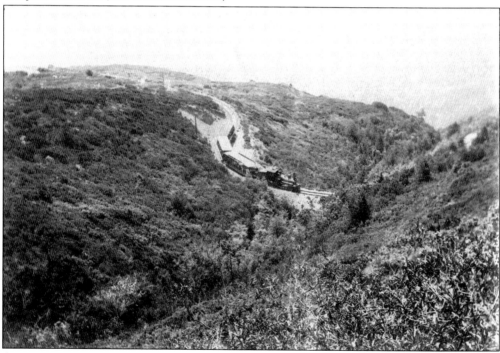

A journey to "the Woods" begins. This is just west of the Double Bow Knot and Mesa Station. The train has just passed the last switch before Muir Woods, part of a triangular shaped "wye," which was useful for turning trains around and much more conventional than a turntable. Mill Valley's Cascade Canyon lies below in the haze of the background. (Ted Wurm collection.)

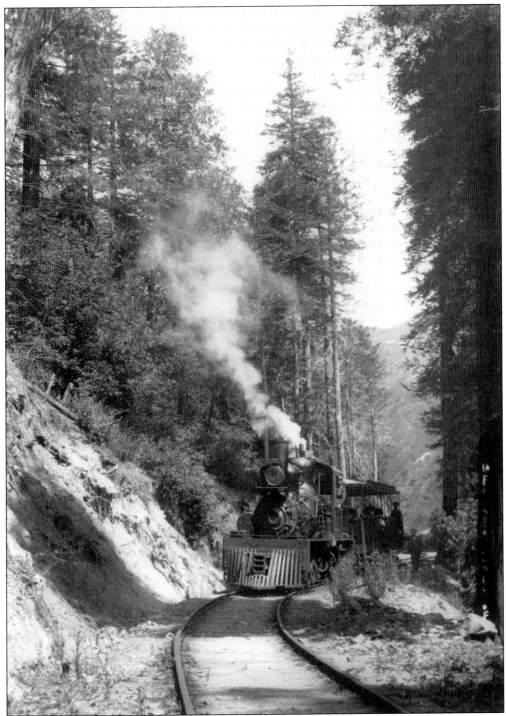

In a scene radically different from the rocky chaparral-covered summit of Mount Tamalpais, it is hard to believe that 4 Spot is working on the same railroad, heading into the trees of Muir Woods. When it came to scenery, the railroad's passengers certainly got their money's worth. (Ted Wurm collection.)

Looking back toward the Double Bow Knot, the steep railroad grade on the mountainside is visible. The tracks, just above the roof of the old Mountain Home Inn, pass through a notch cut in Throckmorton Ridge, a place known as Mine Ridge Cut. A small footbridge for hikers (left) straddles the railroad's cut. A modernized Mountain Home Inn stands on the same site today. (Bancroft Library, University of California, Berkeley.)

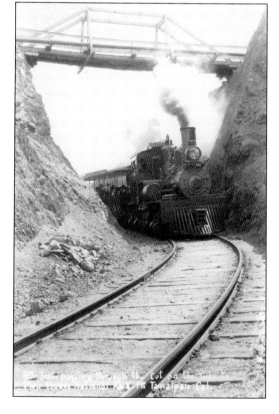

At Mine Ridge Cut, trains passed through Throckmorton Ridge to Muir Woods. The Panoramic Highway replaced the footbridge in 1929, and the gap was filled in 1939. As trains passed beneath the bridge, hikers occasionally tried to drop stones down the engine's smokestack. Seeing a hiker take aim, the crew would launch a belch of black smoke, enveloping the would-be bomber, leaving him shaking his fist at the withdrawing train. (Bancroft Library, University of California, Berkeley.)

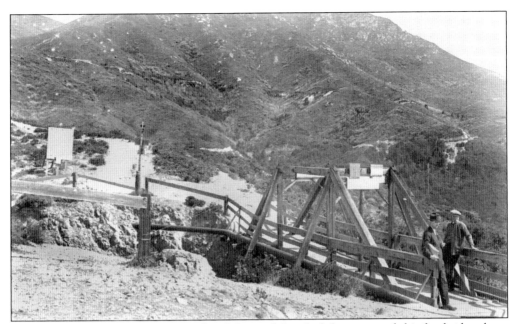

The Pipeline Trail, once a major weekend thoroughfare for hikers, crossed this footbridge above Mine Ridge Cut. Today the trail has nearly vanished, buried beneath pavement or renamed. A piece of the Matt Davis Trail up the hill has bits of the old pipeline embedded in it that once carried Mount Tamalpais water to Belvedere homes. Today a row of mailboxes marks the site of this footbridge. (Ted Wurm collection.)

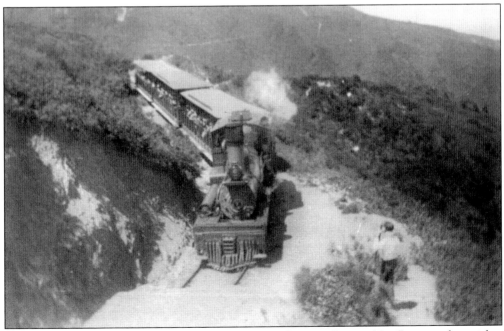

This is the view from the footbridge above Mine Ridge Cut. Engine No. 7 approaches with a brace of cars in tow, heading for Muir Woods. (Ted Wurm collection.)

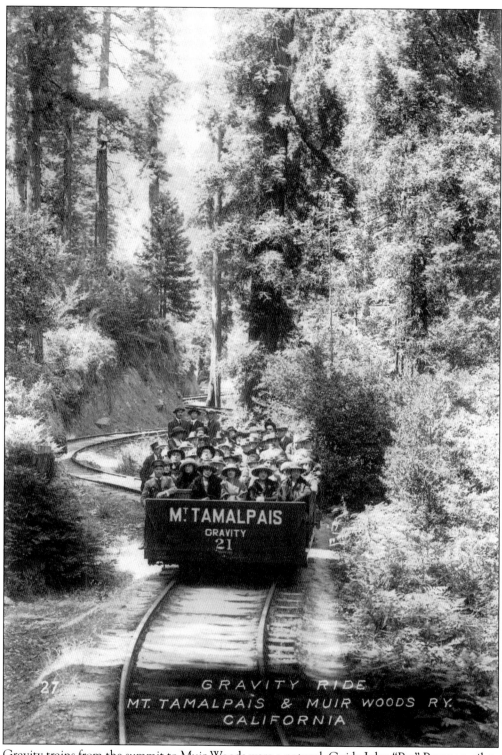

Gravity trains from the summit to Muir Woods were a natural. Guide John "Pat" Paterson pilots gravity car No. 21 through the trees and into the primeval canyon. (Author's collection.)

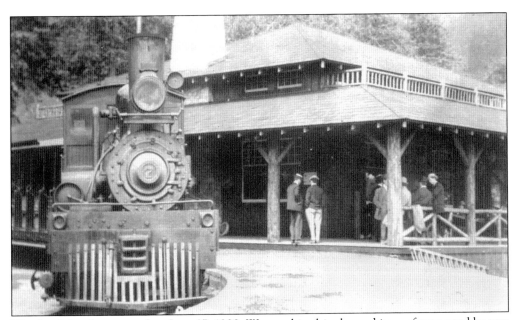

The first Muir Inn opened on June 27, 1908. Wrapped in shingles and its roof supported by tree trunk pillars, the design echoed the rustic character of the Old Faithful Lodge in Yellowstone that opened four years earlier. The telephone number at the new inn was "Main 89, Mill Valley." (Martin/Jennings collection.)

By the stone fireplace inside the first Muir Inn guests could dine at tables covered in fine linen. At night or on cold winter days, the fireplace blazed, and kerosene lanterns glowed from the beams on either side. Larger lanterns hung from ceiling for diners. A large framed photograph of the Double Bow Knot reminded guests of their journey here. (Bancroft Library, University of California, Berkeley.)

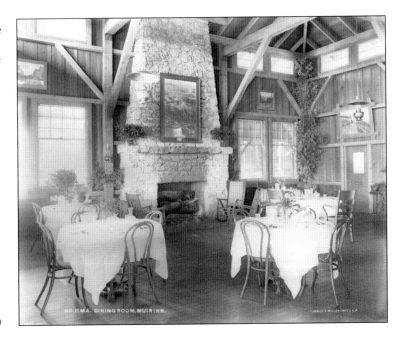

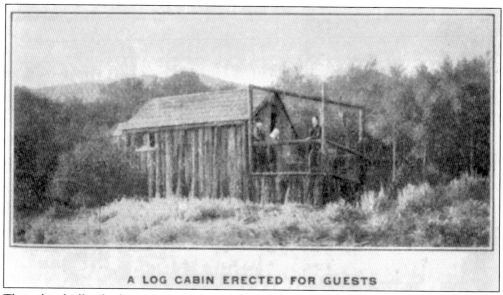

A LOG CABIN ERECTED FOR GUESTS

The railroad offered cabins as guest accommodations, "Some with boarded sides and canvas tops which can be opened allowing all the air desired," stated a Muir Woods brochure. There were also "log cabins for those who do not desire the tent life. . . . Each tent, tent house, and log cabin has a shower bath and water connections. The sanitary conditions are faultless." (Author's collection.)

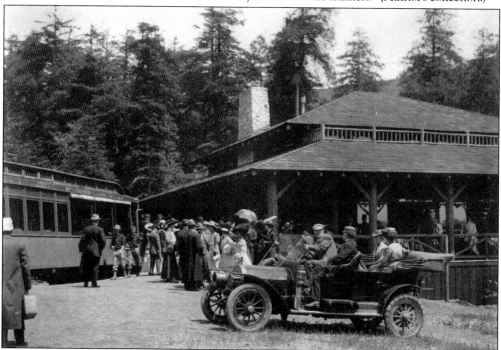

Getting around by automobile in the early 20th century was not for the faint at heart. Marin's dirt roads were muddy in the winter and were sprinkled with oil in the summer to keep the dust down. Snow chains could be necessary to get through Muir Woods's soft soil. This photograph was taken about 1911, when Edith Roosevelt, wife of the 26th U.S. president, visited "the Woods" as a guest of the Kents. (Ted Wurm collection.)

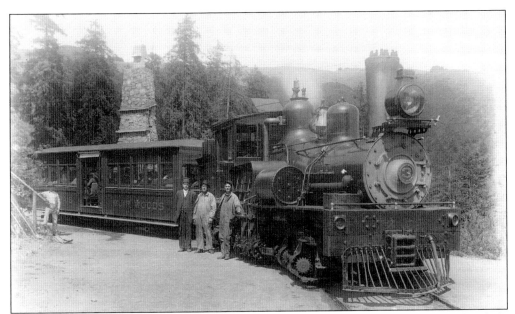

The Muir Inn burned on June 12, 1913, not five years after it was built. In July of 1913, the whole canyon was ablaze as fire threatened both the West Point Inn and the Tavern. As many as 7,000 army, navy, and civilian volunteers came to fight the fire, many by the railroad. The mountainside was charred, but the buildings were saved. After three days, the fire was put out on July 10, 1913. (Bancroft Library, University of California, Berkeley.)

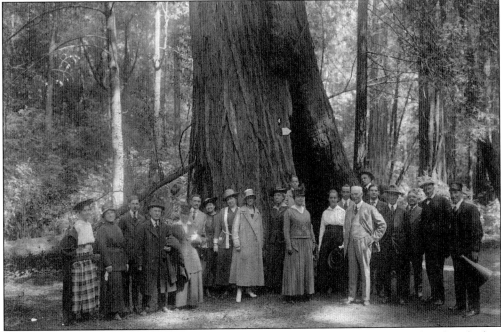

The man with the megaphone is Fred Whitmore, a guide and employee of the railroad in the late 1910s and early 1920s. Whitmore was the guide to Sir Arthur Conan Doyle and his family when they came to Mount Tamalpais on May 30, 1923. Whitmore is mentioned in Conan Doyle's book *Our Second American Adventure*. (Author's collection.)

COTTAGES — MUIR WOODS
MT. TAMALPAIS & MUIR WOODS RY, CALIFORNIA.

After the Fern Canyon fire, the tracks were extended deeper into the canyon, and new facilities were built. The Muir Terminal was at the end of the new extension. Three of the new cabins were alongside the track for overnight stays. A rustic wood-framed walkway led to a footbridge and the new Muir Inn. (Ted Wurm collection.)

Two cabins remained after the railroad was scrapped. Muir Woods visitors now arrived at the far end of the canyon by a toll road. Little used, the last cabins were torn down in early 1938. (Nancy Skinner collection.)

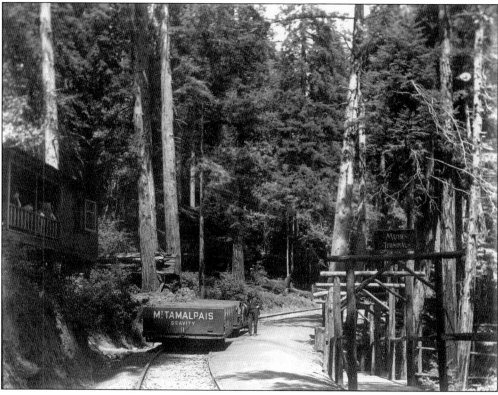

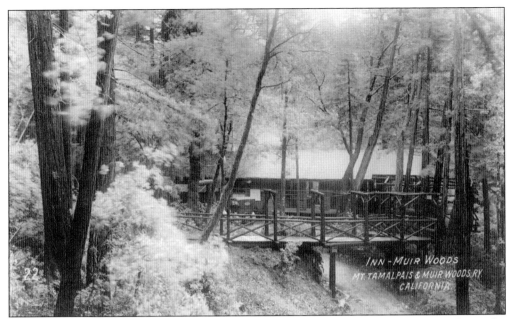

The footbridge spanned the wagon road used by tourists on their way to the canyon floor. The wooden bridge connected the Muir Terminal with the new inn. For a time, there was stage service to the floor of Muir Woods, but it is not clear when that ended. By the late 1920s, Gray Line guides led their guests on foot down the wagon road. (Author's collection.)

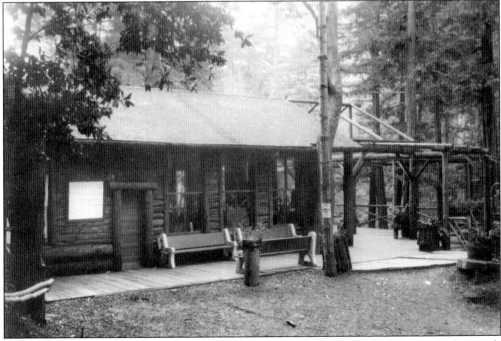

Built to replace the first Muir Inn when it burned, this more modest inn was deeper in the woods and closer to the canyon floor. Nearby cabins offered overnight accommodations. The building was destroyed when the railroad was abandoned in 1930. The platform on which it stood remained for a year and was destroyed in 1931. (Ted Wurm collection.)

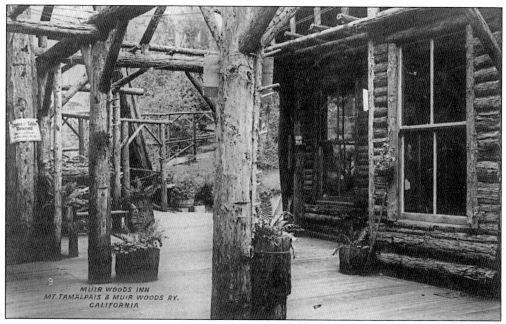

MUIR WOODS INN
MT. TAMALPAIS & MUIR WOODS RY.
CALIFORNIA

A deck wrapped around the inn and was used as a place to sit, think, breath the forest air, and perhaps write a postcard. The view here looks back up the footbridge toward the Muir Terminal. A sign notes, "Chairs and tables are reserved for guests." (Author's collection.)

The restaurant of the first Muir Inn offered an a la carte menu at popular prices. The second Muir Inn had buffet food service in the last years of the railroad. (Ted Wurm collection.)

Nine

BURNED AND SCRAPPED

On a hot summer day in 1929, a thin veil of smoke collected over the lower ridges of Mount Tamalpais. It gathered slowly that morning, but by late afternoon it was clear something more ominous was happening. A huge blaze came sweeping down the mountain toward the town center. By some stroke of luck, the wind changed direction and forced the flames back up the mountain and away from town. By July 5, 1929, Mount Tamalpais had a large scar made of ash and cinder. The railroad that carried firefighters to the blaze was burned too. All the woodwork on engine No. 7 was seared away, and the passenger car it towed became a pile of metal parts. The railroad quickly rebuilt and went back to work. Despite the quick return to service, the Crookedest Railroad was irrevocably doomed. Even before the fire the mountain railroad was showing its age. The rails were worn and so was the rolling stock. Bill Thomas, now the railroad's superintendent, had estimated it would cost $250,000 to rebuild the railroad. Ultimately it yielded a mere $15,000 in scrap value. For a railroad whose assets were the vistas it featured, its buildings all standing on leased land, there simply was not enough capital to continue. When the Panoramic Highway opened on Mount Tamalpais, ridership plummeted to less than a full train on Sundays, previously the big day of the week for the railroad.

On July 2, 1929, a fire began on the slopes of Mount Tamalpais. A dry summer wind spread it, threatening the railroad and the town of Mill Valley. Jake Johnson piloted engine No. 8 from the summit down through the flames. Colorful stories of blistering paint, singed hair, and bloodshot smoke-strained eyes are told. The fire, visible at night 100 miles away, burned to within 100 feet of the Tavern. (Martin/Jennings collection.)

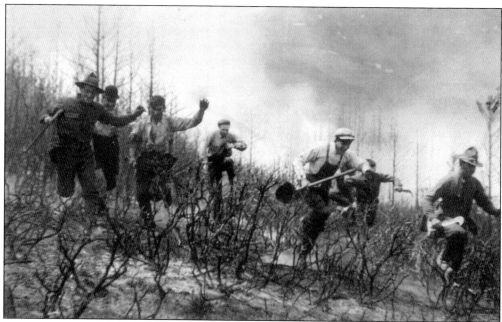

Thousands of volunteers fought the fire on Mount Tamalpais in the dry summer heat. As the wind shifted direction, firefighters ran, looking for some kind of safety in the smoke and heat. (Martin/Jennings collection.)

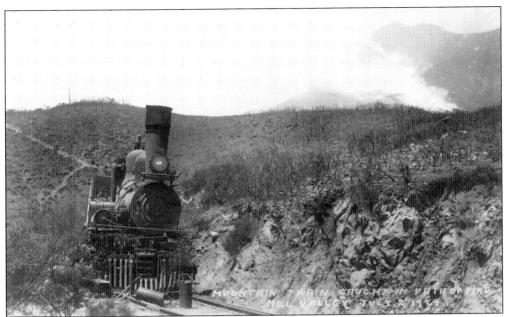

The charred metal remains of engine No. 7, abandoned just below the Double Bow Knot, await rescue as the slopes of Mount Tamalpais smolder in the background. Engineer Volley Thoney and a carload of firefighters were stopped here by the flames. The firefighters abandoned their extinguishers and followed Thoney and his fireman to a gravity car at Mesa Station, where they rode to safety in Muir Woods. (Lucretia Little History Room, Mill Valley Public Library.)

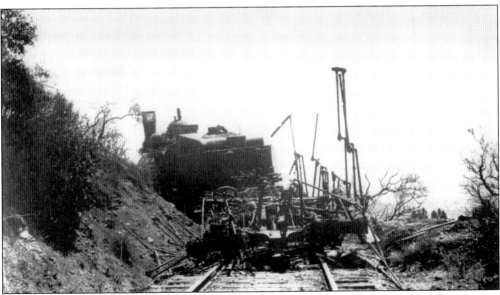

The damaged track was quickly repaired and service resumed, offering a close look at the fire damage. Gravityman Bob Smith said, unfortunately, it was not a great attraction, "The ride was dismal at best. An unpleasant depressing odor of smoke and ash hung over the area for weeks." There was a short-lived flurry of curious sightseers. The last passenger train ran on Mount Tamalpais on October 31, 1929. (Nancy Skinner collection.)

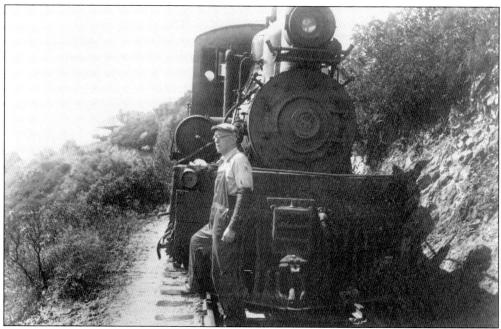

Jake Johnson, the railroad's senior engineer, had worked all 34 years the scenic railway operated. Johnson stands before his favorite locomotive as work crews rip up the tracks behind her. This was the end of an era. The railroad that built the West Point Inn had now abandoned it. The inn, visible in the background, continued as a commercial operation, but now it was harder to get supplies and guests to West Point. (Lucretia Little History Room, Mill Valley Public Library.)

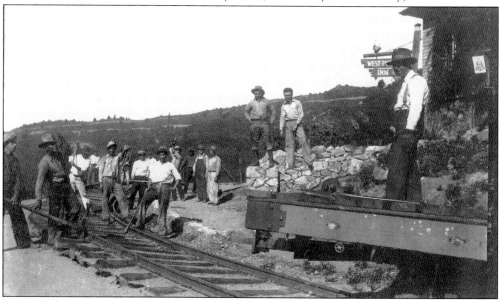

Scrappers began ripping the rails from Mount Tamalpais in the summer of 1930. By September, they were nearing West Point. Rails were jacked from the mountain soil, and the ties were pounded from them. The rusted bolts that fastened the rails together were sheered off. The men collected spikes, rails, ties, and tie plates and stacked them on two stripped-down passenger cars. (Lucretia Little History Room, Mill Valley Public Library.)

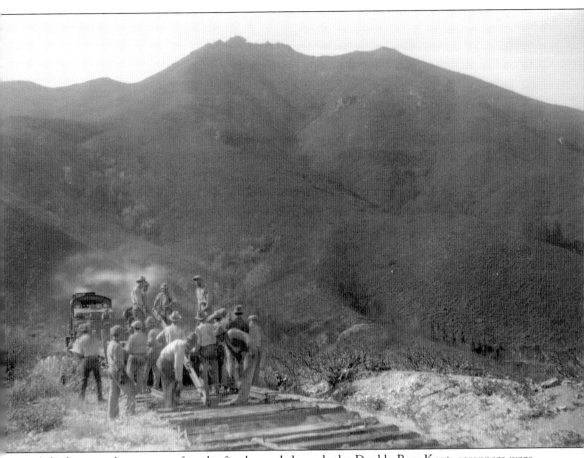

A little more than a year after the fire burned through the Double Bow Knot, scrappers were pulling the restored rails from the mountain, leaving pieces strewn in a rutted roadbed. A hiking newsletter stated with a note of incredulity, "The Mountain Railroad has been sold as junk." Mickey O'Brien, editor of the *California Out of Doors*, wrote, "Every hiker on Tamalpais will view with regret the passing of the Crookedest Railroad." (Lucretia Little History Room, Mill Valley Public Library.)

A decade after the mountain railroad was scrapped, passenger rail service ended in Mill Valley on September 30, 1940. Greyhound buses stand by to begin service where the mountain trains once waited, ready to replace the trains and ferries of the Northwestern Pacific Railroad. The depot will be called the Bus Depot. Today it is a café. At Throckmorton Avenue and Bernard Street was a bar called Osgood's, which was run by railroad guide Bill Osgood. (Ted Wurm photograph; Lucretia Little History Room, Mill Valley Public Library.)

Ten

EPILOGUE

It has been said that with enough determination anyone can move mountains. Almost as difficult would be to put the Crookedest Railroad back on Mount Tamalpais. But it is possible to give people a sense of what it was like when trains were on the mountain. In 1996, volunteers from California State Parks, a group known as the Mount Tamalpais Interpretive Association (MTIA), put the first steam whistle on Mount Tamalpais since Jake Johnson and engine No. 8 had made their last run. August 18, 1996, was the centennial of the driving of the last spike and a mountain-wide celebration was created, stretching from the Mill Valley depot up the Old Railroad Grade to the summit of Mount Tamalpais. There was music all day at the depot, a pancake breakfast at the West Point Inn, and a miniature live steam Shay engine in the parking lot at East Peak, the first Shay since 1930 running on the mountain. The focal point of the day was a flatbed truck with a historically accurate steam whistle and 150-pound brass bell, both borrowed from Shay locomotive No. 9 of the Roaring Camp and Big Trees Railroad near Santa Cruz. The truck made one run up and back on the old grade with an air compressor to sound the whistle and an 88-year old fireman to ring the brass bell just as he had 68 years before. His name was Bill Provines, the last fireman of the Crookedest Railroad. It was a tribute to a colorful piece of Marin history. For the first time in many young lives, people could know what it sounded like when a steam whistle blew on the ridges of Mount Tamalpais. Tamalpais railroad historian Ted Wurm and Ralph Kliewe, who had lived at the West Point Inn when the trains came every day, were also riding on the truck. A doorway to the past had been opened. The MTIA has sponsored many such activities, with the Whistle Truck and without. At East Peak, construction of a small building called the Gravity Car Barn is nearing completion as this book goes to press. It will house a facsimile gravity car, photographs and displays about the scenic railway, and a tribute to the greatest one-day trip in America on the Crookedest Railroad in the World.

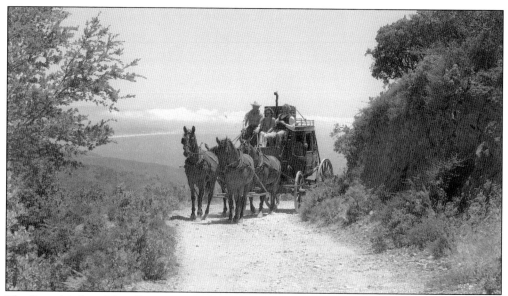

The first whistle at Mesa Station since the railroad's scrapping arrived exactly a century after the railroad drove its ceremonial last spike. On August 18, 1996, a truck with a proper whistle and bell left the Mill Valley Depot and made a run up the Old Railroad Grade, blowing the whistle at all the old crossings and having former fireman Bill Provines (right) ring the bell as he had 68 years before. (David Fontes photograph.)

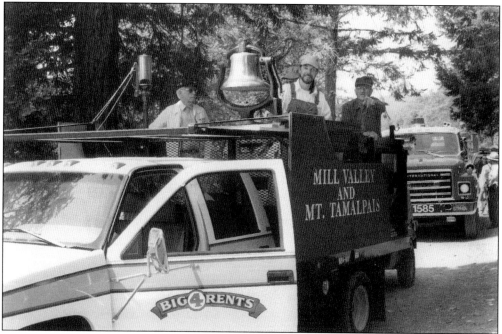

The MTIA put the first stagecoach in 89 years on the Old Stage Road of Mount Tamalpais. For West Point Inn's centennial in 2004, four horses pulled a 150-year-old Concord stagecoach. They met the whistle at the inn in the afternoon, an imitation of what the railroad had done. Speeches were given, a small brass band played, and "America the Beautiful" was sung a capella at the old inn. (Robert Rydjord photograph.)

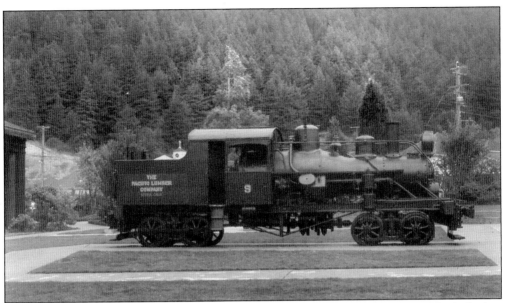

The only surviving piece of rolling stock from the Crookedest Railroad is engine No. 9, the last locomotive purchased by the railroad. It spent four years on Mount Tamalpais and the rest of its days in forest logging. No. 9 has been on display in Scotia, California, since 1950 and is the only surviving piece of the Mount Tamalpais and Muir Woods Scenic Railway. (Pete Martin photograph.)

The MTIA's Gravity Car Barn stands at the north end of the Crookedest Railroad's summit yard. It will be a place to learn about Mount Tamalpais's scenic railway right where it worked. When open, the barn will have displays of the railroad and its operations. It will feature a facsimile gravity car that will roll out on freshly laid rail to a spot where gravity cars awaited duty a century before. (Author's collection.)

DISCOVER THOUSANDS OF LOCAL HISTORY BOOKS
FEATURING MILLIONS OF VINTAGE IMAGES

Arcadia Publishing, the leading local history publisher in the United States, is committed to making history accessible and meaningful through publishing books that celebrate and preserve the heritage of America's people and places.

Find more books like this at
www.arcadiapublishing.com

Search for your hometown history, your old stomping grounds, and even your favorite sports team.

Consistent with our mission to preserve history on a local level, this book was printed in South Carolina on American-made paper and manufactured entirely in the United States. Products carrying the accredited Forest Stewardship Council (FSC) label are printed on 100 percent FSC-certified paper.

MADE IN THE
USA